magritte

Great Modern Masters

Magritte

General Editor: José María Faerna

Translated from the Spanish by Alberto Curotto

CAMEO/ABRAMS

HARRY N. ABRAMS, INC., PUBLISHERS

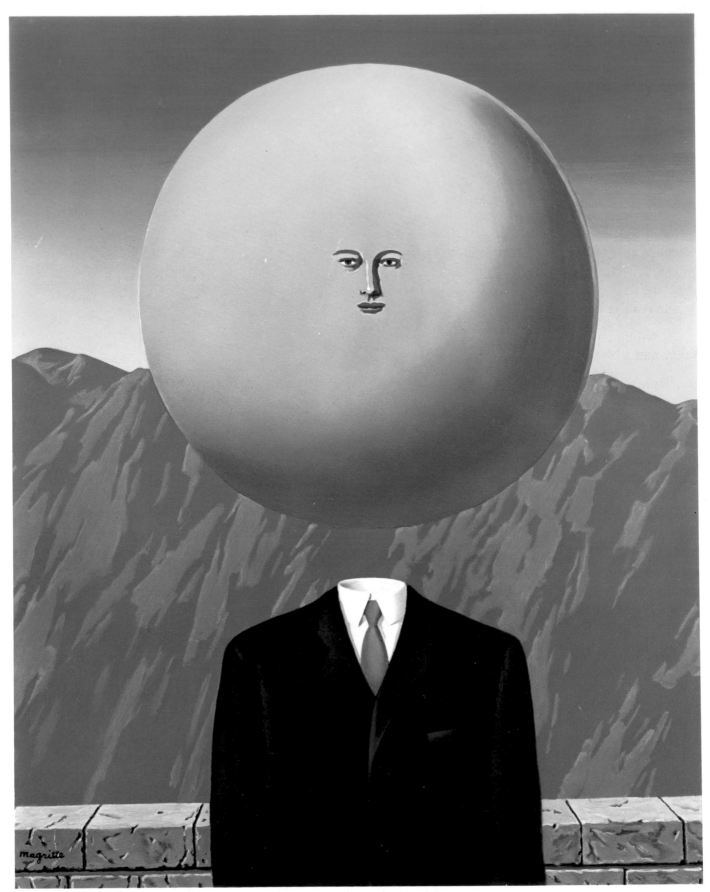

The Art of Living, *1967. Oil on canvas, 25½ × 21¼″ (65 × 54 cm). Private collection.*

Magritte's Surrealism

In December 1929, two years after joining the ranks of the Paris Surrealists, René Magritte published his most important contribution to *La Révolution surréaliste*, the journal that served as the group's main avenue of communication. In a box, below the title *Words and Images*, Magritte made eighteen little drawings, each accompanied by an aphoristic statement. Thus, "an object never performs the same function as its name or image" is illustrated by the likeness of a horse portrayed in a painting and by a person uttering the word "horse"; "an object's relation to its name is never so close as to make it impossible to find a more fitting one" is followed by the drawing of a leaf and the word "cannon"; a woman saying "the sun" is paired with the sentence "a word can substitute for an object in reality," and so forth.

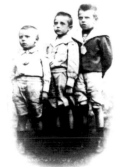

René Magritte, on the right, with his two younger brothers, Paul and Raymond.

Reality and a New Order

This simple manifesto encapsulates the essence of René Magritte's work. Magritte's paintings are grounded in the awareness that the link between objects and their names, meanings, and functions is much more precarious than one may be led to believe from the routines of everyday life. As a painter Magritte took it upon himself to suggest new ways of organizing reality. "The universe is changed," wrote Louis Scutenaire of his friend Magritte, "nothing is ordinary anymore." In this respect, Magritte's painting is conceptual and alien to such typical values of the painterly tradition as color, texture, and the contrast between light and shadow. Magritte's work is a critical and revelatory type of art that challenges the fixed and established order of reality as the necessary condition of the mind. This goal was closely linked to the Surrealist movement, although Magritte did not always agree with the methods of some of the Surrealists.

An example of Magritte's poetic association of images.

The Paris Surrealists

As in many other cases Magritte's career as a Surrealist began even before he first made contact with members of the group or their leader, André Breton. The most profound influence on Magritte was the work of the Italian painter Giorgio de Chirico, whom the Belgian artist met in the 1920s. In the beginning Surrealism was principally a literary movement, made up of writers like Breton, Louis Aragon, Paul Eluard, and Antonin Artaud. Their primary modus operandi was "automatic writing"—the free-floating association of images, unhindered by the conscious mind—as a means of releasing the world of dreams and desire. Surrealist painters followed as closely as they could the same guiding principles as their literary counterparts, but the automatic processes were more limiting when applied to the plastic arts. And many of the Surrealist painters eventually gave up on them. However, almost all of them remained true to the Freudian unconscious as the source of their activity.

In this Magritte departed from the other Surrealist painters: the free associations of the dream state were not, in fact, at the root of his art;

Magritte and Georgette Berger in 1922, the year they were married.

Magritte at work in 1963.

This drawing, from a series entitled The Lesson of the Things, *is accompanied by the caption "Seen from the inside," and is part of a sequence about the poetic possibilities of a head and a top hat.*

vue de milieu intérieure

The painter's atelier/living room in 1965; the painting with objects of impossible dimensions and properties is typical of his works.

his paintings instead resulted from a rigorous, logical intellectual process of discovering unusual realities in everyday life. This is perhaps why his association with Breton—that is to say with canonical Surrealism—was always tenuous; the two men maintained a constant but distant relationship.

Conceptual Games

In his paintings Magritte uses objects that are familiar to the viewer. And if some are not at first familiar, they become familiar as the artist repeats many of them throughout his works. But although he represents these objects in a realistic, objective way, he establishes unsettling relations between them. This turn of events is produced several different ways: from simple dislocations—forests of wooden balusters, bells floating in midair; to conflicting associations—a face made from a woman's naked torso, with its breasts becoming the eyes and its genitals the mouth; or paradoxical associations—clouds flowing through open doors, painted landscapes melting into the real landscape that they represent.

Throughout his career, Magritte continuously refined and reinvented this conceptual game, making the most of any possible associations—or disassociations—that might exist between objects. His subtle but graphic metaphors appealed to the advertising world and many of his images are now familiar corporate icons: an eye superimposed on a cloudy blue sky became the logo for CBS television and the Belgian airline Sabena used a variation of his soaring "sky-bird" as their symbol. In time the unusual associations of common images would be complemented by objects transformed into different objects, with which they shared some type of relation, either by proximity or by opposition. Thus an apple or the disk of the sun can occupy the space of a person's missing head, while the veins of a leaf can hold and accommodate birds like branches on a tree.

René Magritte 1898–1967

Magritte was born in the small Belgian town of Lessines, about forty miles southwest of Brussels. Apart from a few years in Paris in the 1920s, Magritte spent his life in Belgium, moving often, since childhood, from town to town. His father, Léopold, was a tailor and later owned successful food businesses. His mother, Régina, who had been a dressmaker and a milliner before getting married, committed suicide by jumping into the Sambre River at Châtelet, near Lessines, in 1912. The impact of this tragic event on the young Magritte can be seen in many of his paintings made years later. In both *The Central Story* (1928) and *The Lovers* (1928) there are figures whose heads are covered by a cloth, reminiscent of the nightgown that was said to be wrapped around his mother's face when her body was found in the river. In 1913 Magritte's family moved to Charleroi, where he met Georgette Berger. He did not see Georgette again until 1920,

but in 1922 the two were married and remained together for the rest of their lives.

Magic and Painting

Magritte told the story of how one summer, as a child, he and a little girl used to play in a nearby cemetery, exploring the dark crypts together. One evening as they were leaving the graveyard, Magritte caught sight of a painter in a nearby poplar grove. This single image somehow gave the young Magritte the sense of painting as a magical act, charged with revelatory powers. Indeed, a sense of the magic and mystery in art remained with Magritte throughout his life and, interestingly, his art later came to be described as "magic realism."

Magritte took art classes as a child but started a more formal pursuit of the arts in 1916, when he began to study at the Académie des Beaux-Arts in Brussels. Like many other painters of the period, he was heavily influenced by the Impressionists, but soon discovered the works of the Italian Futurists, particularly Giorgio de Chirico. Magritte was moved to tears when he first saw a reproduction of de Chirico's *The Song of Love* (1914) around 1923. He described it as "a new vision through which the spectator might recognize his own isolation and hear the silence of the world."

In the early 1920s Magritte earned a living designing wallpaper for the firm Peeters-Lacroix and making commercial drawings. During this time he met several young like-minded writers and artists, including Pierre Bourgeois, E. L. T. Mesens, Camille Goemans, Marcel Lecomte, Paul Nougé, and André Souris; together they eventually formed the Belgian Surrealist group.

Unlike their more flamboyant Parisian counterparts, the Belgian Surrealists conducted their artistic and philosophical forays from the obscurity of bourgeois lives—they were wallpaper designers, schoolteachers, biochemists, and civil servants. Describing the decidedly "non-surrealist" decor of the home of his friend Magritte (who never had an "artist's studio," preferring instead to paint in his family room), Goemans wrote: "What I wanted to show, by referring to Magritte's day-to-day behavior, was that Surrealism doesn't necessarily imply a rowdy, tempestuous existence, it doesn't imply a rigorous refusal to live more or less like everyone else in conditions we have been given, and that it is possible to be a Surrealist even when one pays one's taxes and obeys traffic regulations."

Surrealism in Paris

By 1925 Magritte had already given up a traditional representation of objects. The unsuspected or unexplored relations between them as a source of poetry and provocation were to become the backbone of his entire oeuvre. In 1927, when Magritte had his first one-person exhibition at Le Centaure gallery in Brussels, these principles were already established. During this time the artist and his wife lived for three years in Le Perreux-sur-Marne, just outside of Paris. Here, thanks to his Belgian friend Goemans, who had opened a gallery in Paris, Magritte met André Breton and the Surrealist painters. Together with Max Ernst, Jean Arp, Joan Miró, and Salvador Dalí, Magritte showed some of his works in the Surrealist exhibition of 1928 at Goemans's gallery. Magritte initially participated in all the

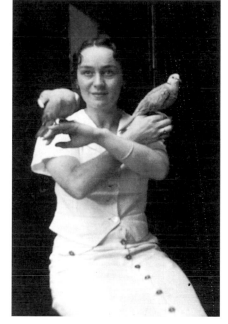

Georgette Magritte photographed with doves in 1937.

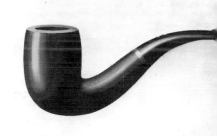

This Is Not a Pipe, *1928–9. Magritte painted several versions of this picture, a paradigmatic one of the conflict between object, word, appearance, and function.*

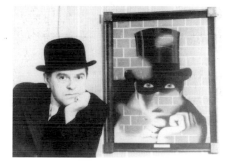

Magritte in 1938 with The Savage, *a work that he had painted ten years earlier, inspired by the covers of the pulp thrillers that he loved to read.*

Magritte in 1960, photographed by Suzi Gablik, who wrote an important monograph on the artist.

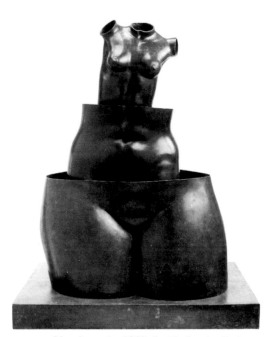

Megalomania, 1967. Just before he died Magritte began making sculptures, often based on his paintings. This one was cast in bronze the year of his death and is inspired by a picture that he had painted six years earlier.

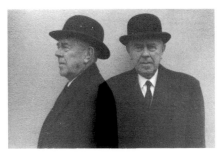

A double portrait of the artist in the bowler hat worn by so many of the characters in his paintings. The year of this portrait, 1965, Magritte traveled to the United States for the opening of the New York retrospective of his work at The Museum of Modern Art.

activities of the group and contributed to *La Révolution surréaliste*, whose last issue included his *Words and Images*, a genuine manifesto of Magritte's painterly ideology.

A Straight Path

After he moved back to Brussels in 1930 Magritte's association with the Parisian group continued but took on a less-intense character; he contributed *The Rape* in 1934 for the jacket of Breton's *Qu'est-ce que le Surréalisme?* and the cover image for the tenth issue of the Surrealist review *Minotaure*, in 1937. The previous year Magritte had his first show in New York and took part in several international Surrealist exhibitions.

During the Second World War Magritte's commercial career was temporarily put on hold, although he continued to paint. The consistency of Magritte's philosophy makes it difficult to speak of an evolution in his work or to distinguish between different phases; but during the war years Magritte embarked on some rare stylistic experimentations. Belgium was invaded by Germany early on and perhaps in an attempt to raise his spirits from the gloom of occupation, Magritte began painting in a colorful, exuberant style known as his "Impressionist" or "Renoir" period. These paintings borrowed the style and subject matter of the Impressionists— reclining female nudes, pastel coloring, loose brushstrokes—but still maintained a provocative element. The hard-core Paris Surrealists, however, frowned upon this body of work

The "vache" period also emerged during the war years and comprised a group of more than twenty cartoon-like, burlesque canvases painted with rough, thick brushstrokes and garish colors, very unlike the clean, subdued qualities of his customary style. However, these were merely parentheses and Magritte subsequently resumed the unmistakable style that has made his canvases so easily recognizable since the late 1920s.

At the end of the war Magritte joined the Belgian Communist Party (he had been active in the party twice before during the previous decade). The party's reactionary position with regard to artistic matters, however, soon caused him to withdraw. While he continued with his own work, he also resumed his Surrealist activities, contributing to manifestos and pamphlets and renewing ties with old colleagues from the Belgian Surrealist group, such as Nougé, Scutenaire, and Marcel Mariën.

The Final Years

In the 1950s Magritte received several large-scale commissions, including the ceiling of the Théâtre Royale in Brussels and the walls of the gaming room of the casino in Knokke-le-Zoute where, in 1952, his works were shown together with those of Paul Delvaux. A large retrospective at the Palais des Beaux-Arts in Brussels two years later established his reputation as Belgium's foremost modern painter. He continued painting—and even took up sculpting—until his death; he also kept up his contributions to several reviews and, beginning in 1957, he created some short films featuring Georgette and their friends. International retrospectives of his work proliferated until the time of his death, including one at the Museum of Modern Art in New York. The images recurring in his works are undoubtedly among the most characteristic of all modern art.

Plates

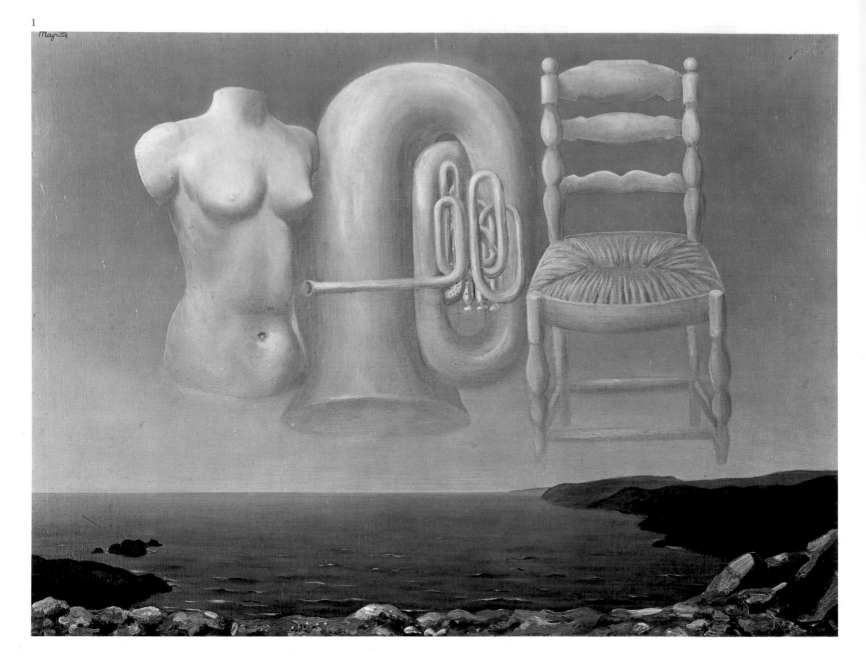

Displaced Objects

"His art has the power to alter our perception of reality," a critic wrote of Magritte. Indeed, while his style of painting is realistic and the objects he paints are often easily recognizable, their context is not: loaves of bread float in the air, a tree is superimposed on a leaf, a balloon takes the place of an eye. This altering of reality through a displacement of objects is the main mechanism that Magritte adopts to reveal the hidden properties of the everyday and evoke the mystery of familiar objects. "The cracks that we see in our homes and our faces," he said, "I have already found more eloquently in the sky; the carved wooden legs of a table would lose their typical innocent existence if they suddenly appeared to dominate a forest." These displacements, greatly influenced by the early collages of Max Ernst, become conceptually more complex when the objects are, in fact, somehow related and not just arbitrarily thrown together. In 1936 Magritte had an enigmatic dream-vision in which he saw a large egg inside a bird cage instead of the sleeping bird that was actually in the cage: "Thus I discovered a new and astonishing poetic secret since the impact of the image was created by the affinity between the cage and the egg, while previously the impact of images derived from encounters of foreign objects bearing no relation to each other."

1 Threatening Weather, *1929. Magritte was often amused, if not irritated, by attempts to explain the significance of his imagery; he hoped that his paintings would inspire ideas rather than express them.*

2 The Voice of the Winds, *1931. Giant sleigh bells floating in midair are recurrent images in Magritte's paintings from the late 1920s; they imply sound, by their nature (and the name of the painting), and yet they seem to hang silently. He once described a painting as a means of hearing "the silence of the world."*

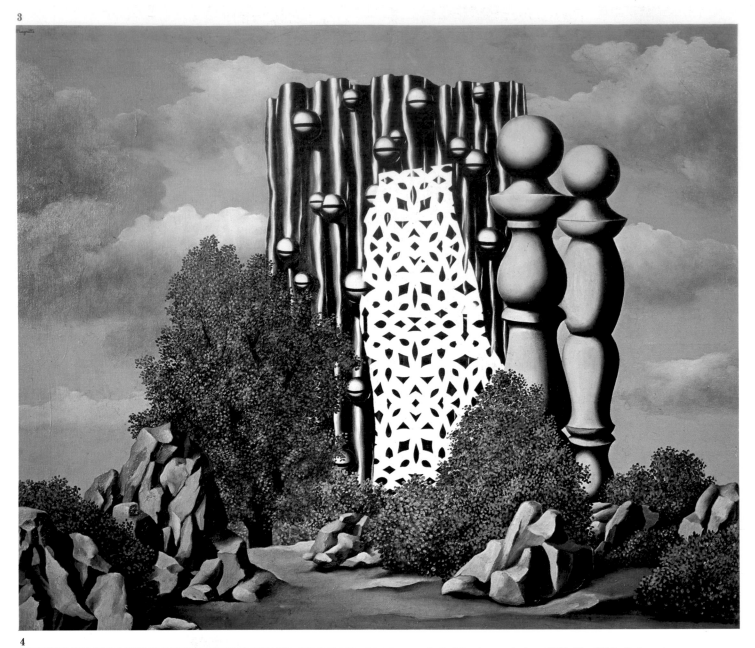

Trois objets près d'un rideau regardent un bateau dans la tempête, d'un balcon en pierre.

3, 4 The Annunciation, *1930.* The Difficult Crossing, *undated. The bells seen in the previous painting reappear here along with another Magritte staple, wooden balusters or table legs, "bilboquets," as Magritte, who was a skilled carpenter, called them in French. In* The Annunciation, *they are displaced in what appears to be a forest of signs. In the drawing, they look like enigmatic characters watching a troubled ship at sea, as indicated by the caption beneath: "Three objects by a curtain looking at a ship in a storm from a stone balcony."*

5 The Traveler, *1937. The association of apparently unrelated objects gives rise to a new shape: the sphere, which reveals an unlikely complicity.*

6, 7 Prince Charming, *1948.* The Dark Glasses, *1951. Objects are transformed by association into one another.* Prince Charming *is an example of Magritte's somewhat grotesque, cartoon-like "vache" style of painting.*

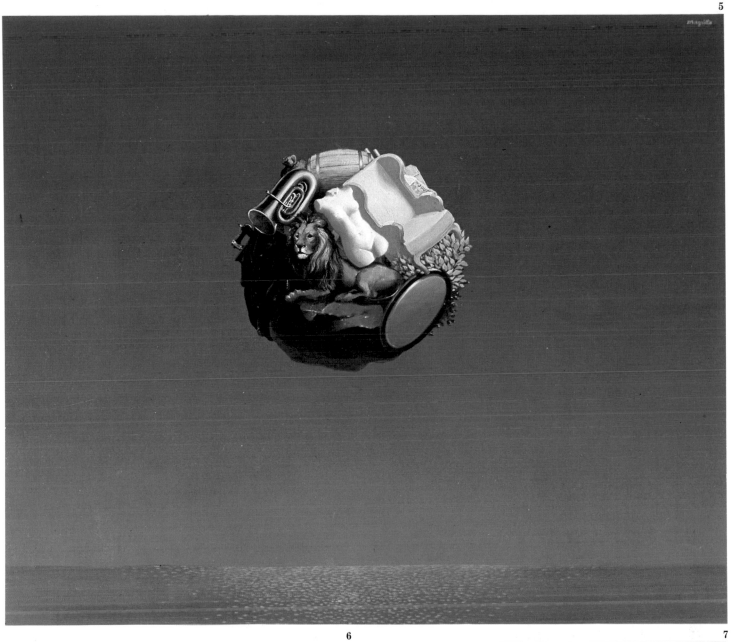

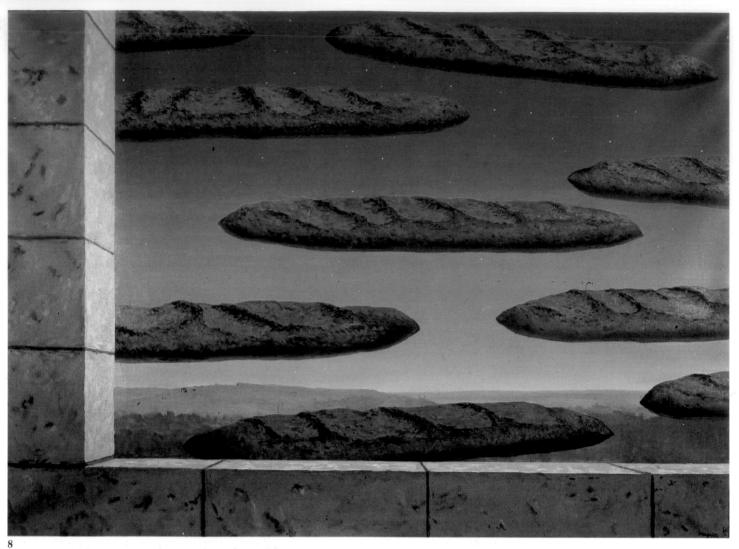

8

8 The Golden Legend, *1958. Baguettes substitute for clouds in the sky.*

9, 10 The Devil's Smile, *1966.* The Last Scream, *1967. The relationships between the superimposed objects are, bafflingly, apparent, making one reconsider even the traditional order of things.*

9

10

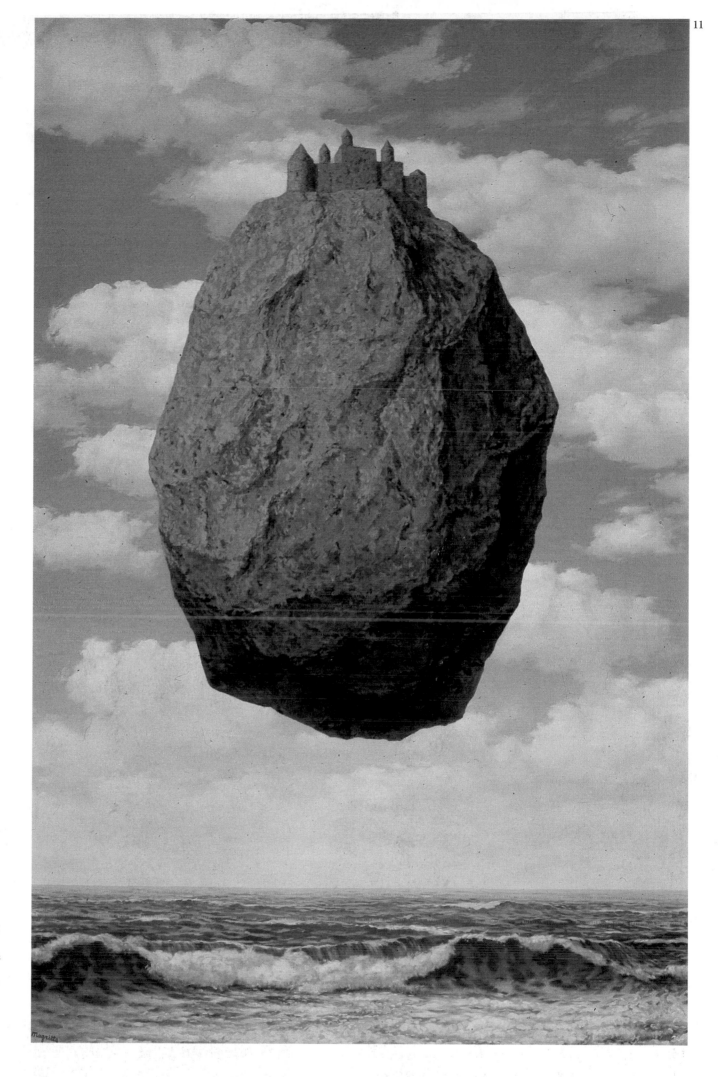

11 The Castle in the Pyrenees, *1959. This painting is monumental both in the bulk of its rocky island protagonist and in the sheer size of its canvas. Magritte began using larger canvases, which were ordinarily less marketable, as his popularity in the United States increased.*

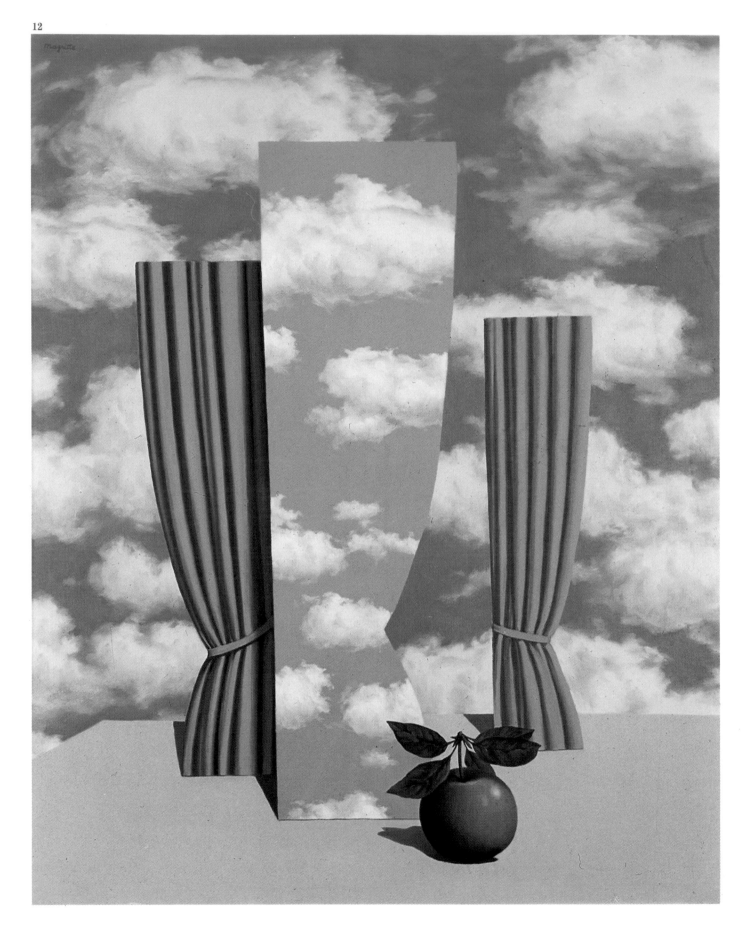

12 The Beautiful World, *c. 1960. Magritte was fascinated by the
cloudy sky as a real and a painted backdrop. Reality, it would
seem, can be simply copied onto a canvas.*

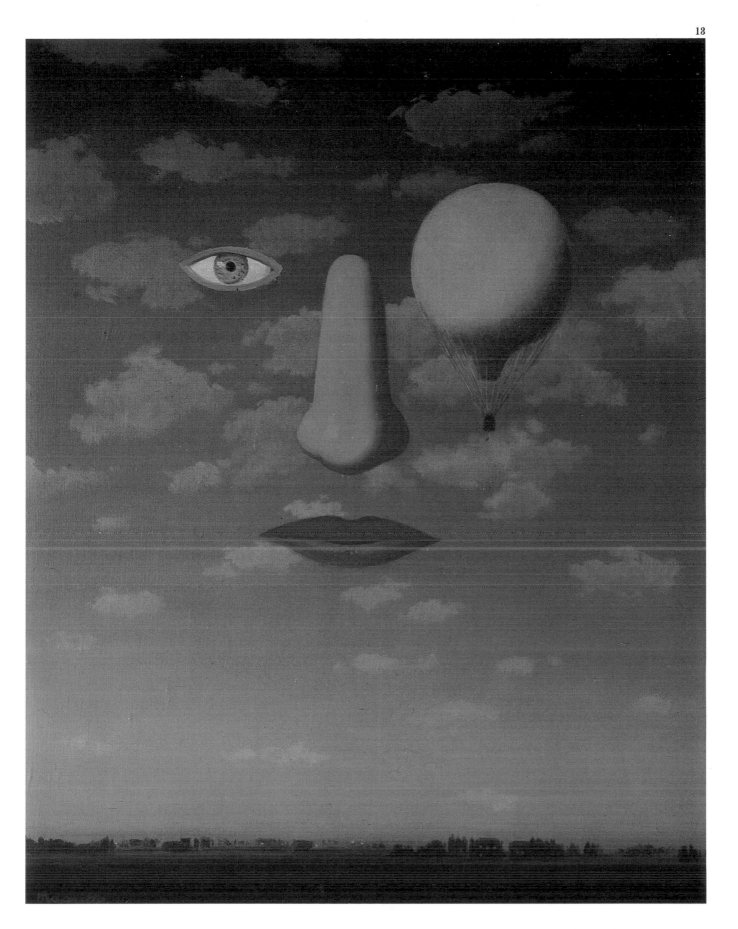

13 The Beautiful Relations, *1967. Three displaced objects enjoy, ironically, a working relationship, producing a new allegorical meaning; something like the face of the universe suddenly appears in the twilight sky.*

Metamorphosis of the Object

In some of his more extreme instances of "displacement," Magritte actually transforms one object into another. His paintings are populated with hybrid beings and objects halfway between two states—"mergings" as Magritte called them. These are actually transference phenomena, since one thing can be mistaken for another to which it is functionally related—the dress or the shoe taking the shape of the body or the foot—or with which it bears some formal similarity—the fish transformed into a cigar. These transferences emphasize the fragility of the conventions that rule language, one of the overriding themes of Magritte's work. In one of his most emblematic paintings, beneath the unmistakable image of a pipe a line of text reads "this is not a pipe" (see page 7). This illustrates the fact that what we see is only the representation of an object and not the object itself, and also leads us to reflect upon the mystery of the most innocent of appearances. Magritte wrote in 1929 that "an object's relation to its name is never so close as to make it impossible to find a more fitting one."

14 Metamorphosis of the Object (A Study for an Ashtray), *1933. "Dear Lady Admirer, Here is the bottom. If a person with ashtrays wants to put a border on it, he should simply put equal concentric circles on a white border: the same white as the drawing. I hope it will please you as much as Cleopatra pleased Bonaparte. Until one of these days soon. Yours, M."*

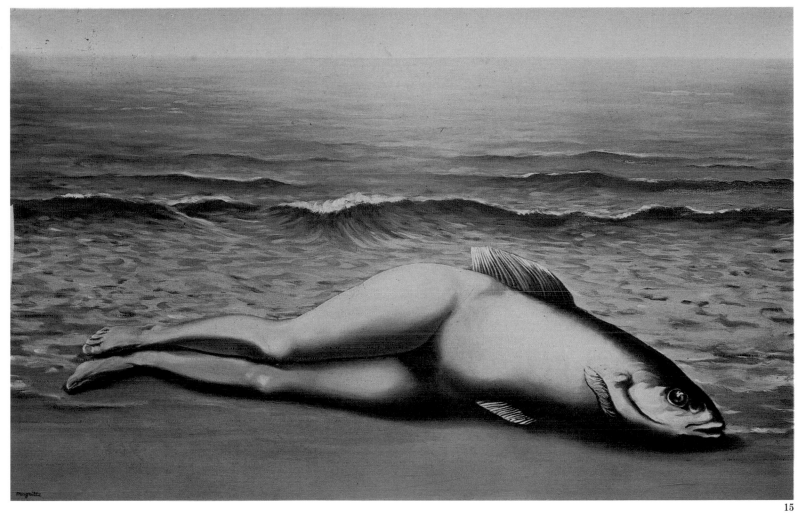

15

15, 16 Collective Invention, *1935. The Exception,* 1963. *Despite their similarities, the criteria ruling the two fishy transformations are different. In the former, the effect is determined by the inversion of a familiar, if fantastical, image—the mermaid, while in the latter, the effect resides in the merging of two entirely unrelated objects.*

16

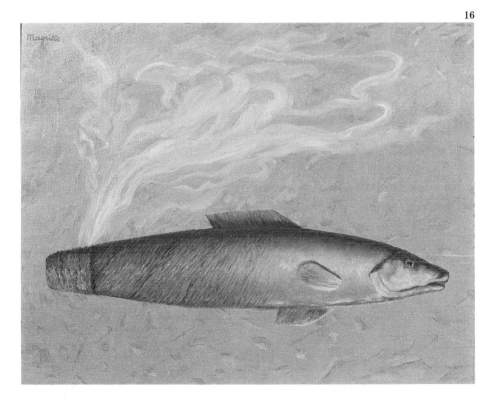

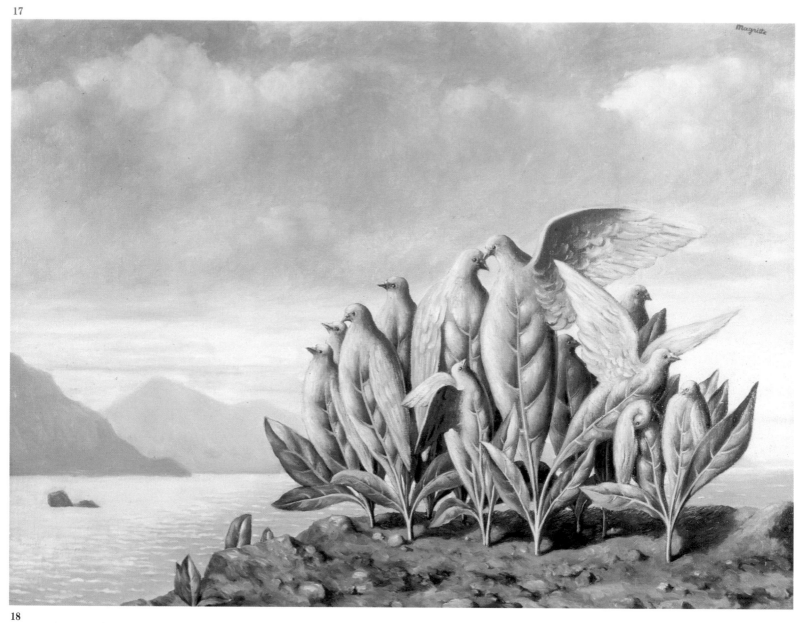

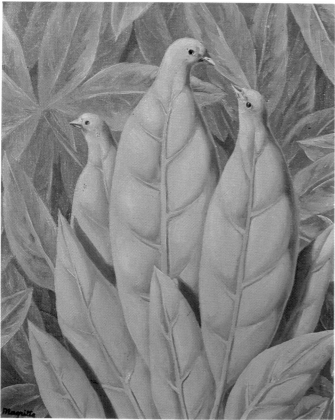

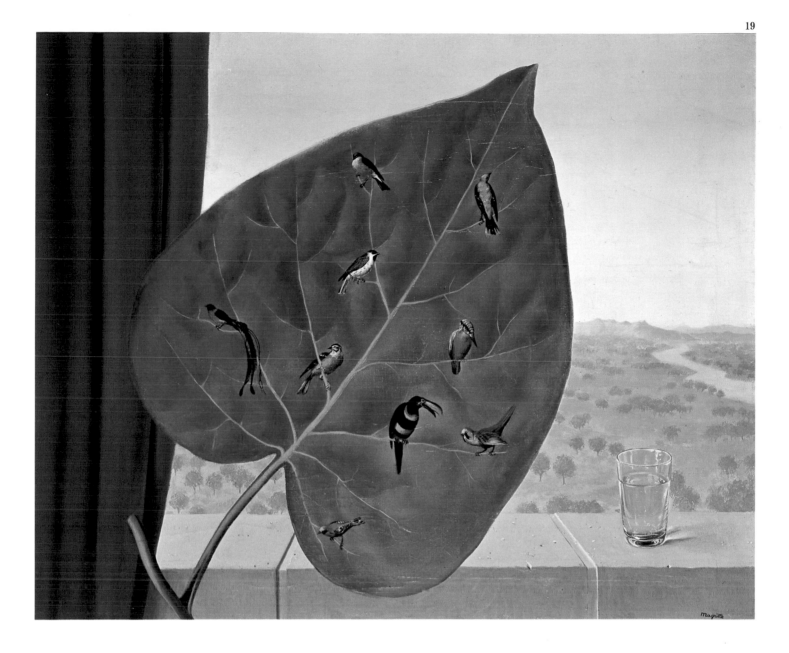

17, 18 Treasure Island, *1942. The Natural Graces,*
1962. Birds, trees, and leaves are always related in
Magritte's paintings. Here birds change into leaves,
endowing an imaginary island and a clump of
leaves with a most mysterious character.

19 The Inward Gaze, *1942. The analogy between the*
veins of the leaf and the branches of a tree is
reinforced by the natural relation between tree,
branch, and leaf. The scale of the birds and the leaf,
as well as their position inside a room, add to the
disconcerting ambiguity of the scene.

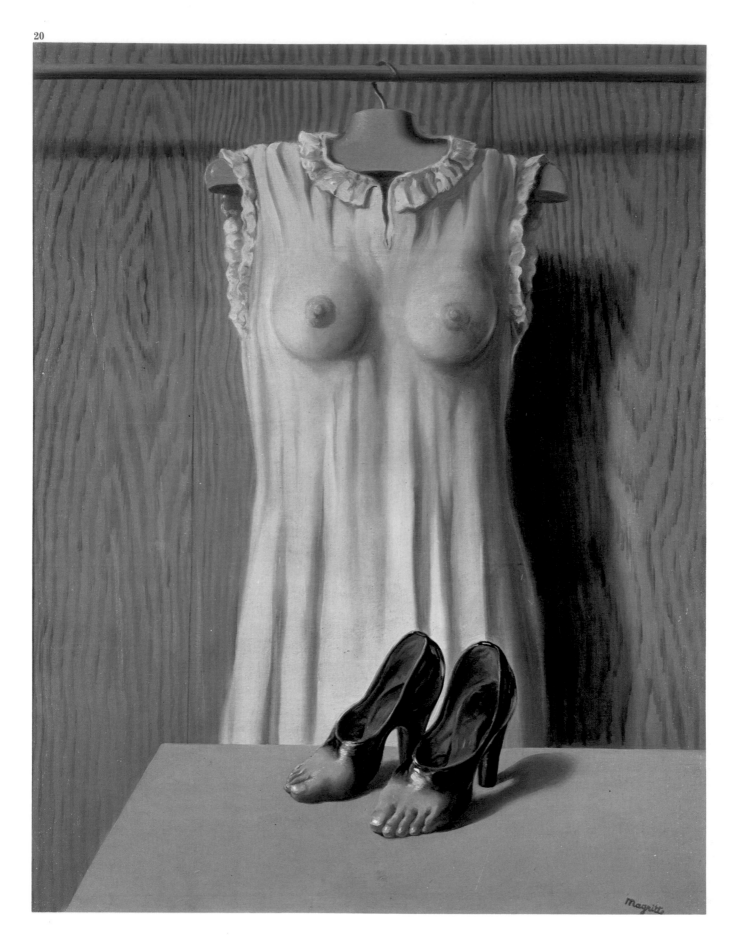

20 Philosophy in the Boudoir, *1947. Magritte was fascinated by the synthesis of objects: a cigar becomes a fish, the landscape is transformed into an eagle, and here, shoes and clothing merge with the body. Magritte had explored this last theme, a nightgown assuming the shape of the body that it is meant to cover, ten years earlier with* In Memoriam Mack Sennett.

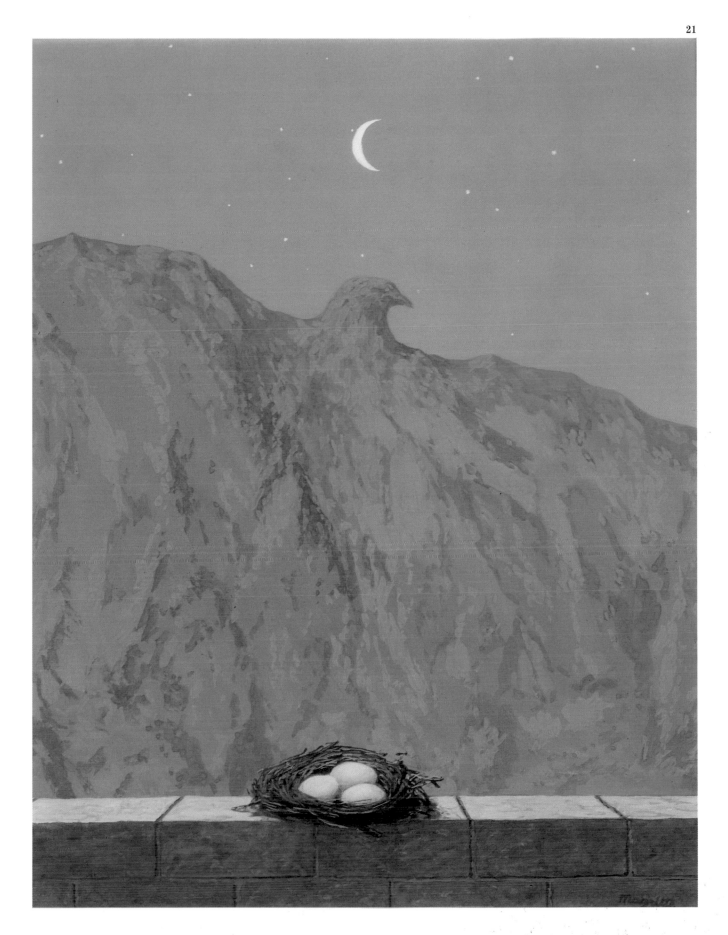

21 The Domain of Arnheim, *1962. Magritte said that this painting "materialized a vision that Edgar Allan Poe would have appreciated." The mountain "finds its perfect form in the shape of a bird spreading its wings," a metamorphosis evidently related to the eggs in the nest on the windowsill, in the foreground. The use of a painting as an imaginary window for the viewer is a constant feature of Magritte's work.*

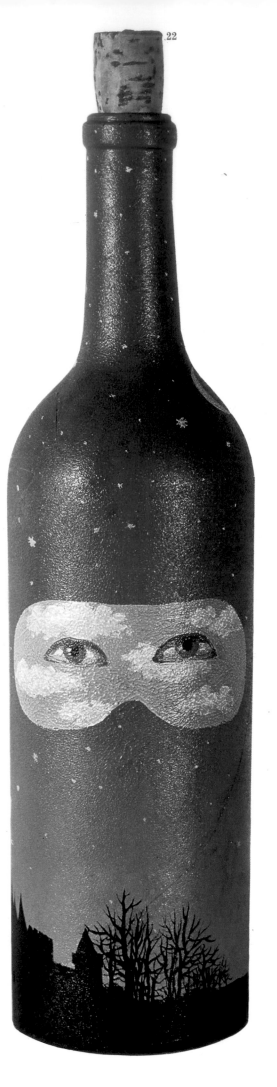

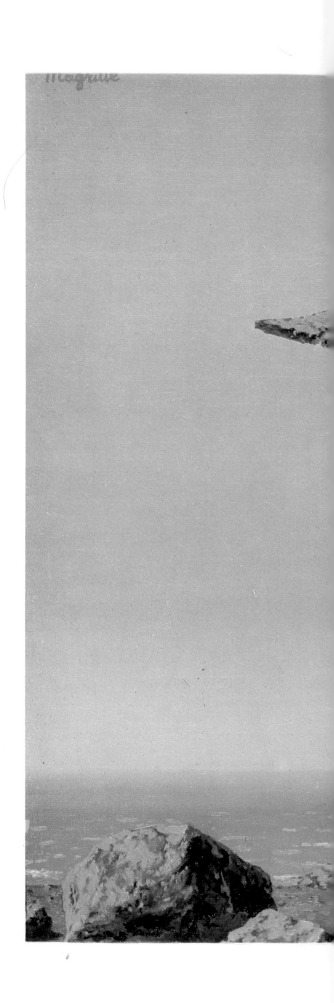

22 *Painted bottle, undated. Magritte began painting bottles during the Second World War, when canvas was hard to come by. This was one of a few artistic experiments that he made during the war years. This example is no doubt from the forties, although few of the bottles are titled or dated. A genie or spirit trapped inside peers out into a starry sky.*

23 The Idol, *1965. As in* The Domain of Arnheim, *a bird appears to be contaminated by the rocky world along the coast, in odd contrast to the weightlessness of flight.*

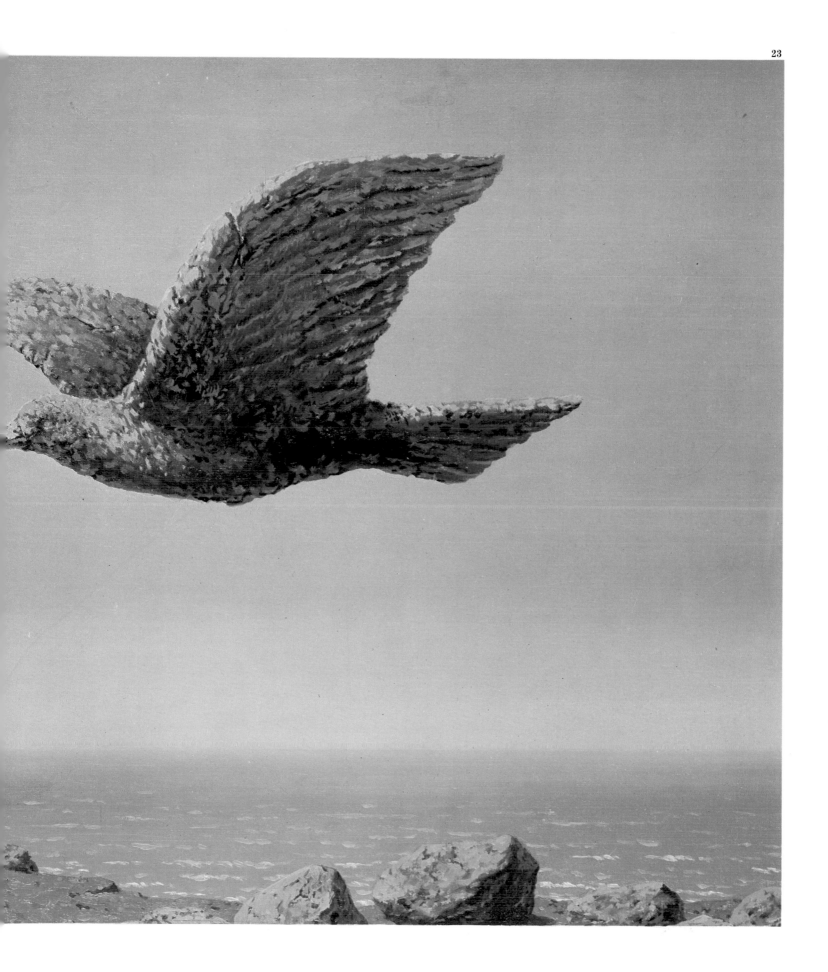

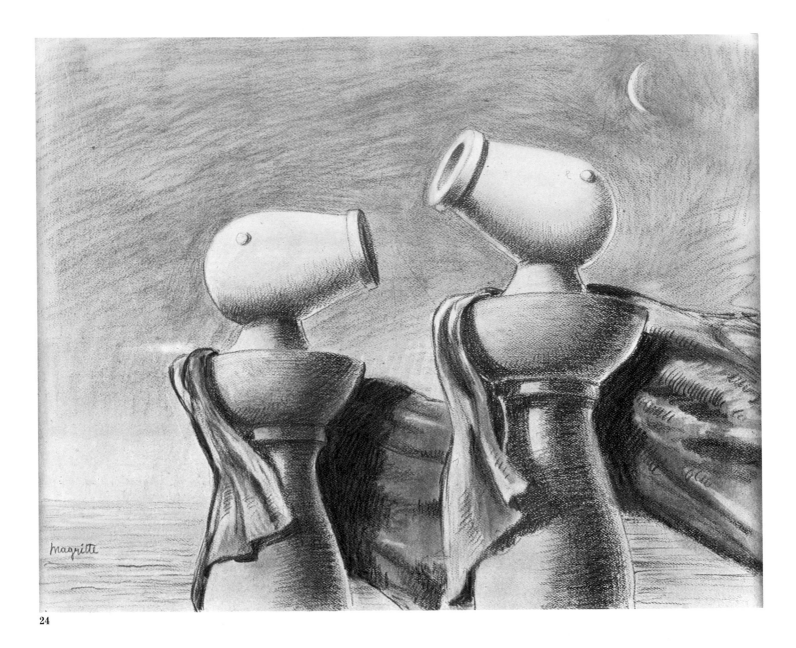

24

Conflicting Images

The main function of painting, according to Magritte, is to convert a gaze into a tool of knowledge, forcing one "to think in distinct, unaccustomed ways." To achieve this goal, the familiar objects that constitute Magritte's thematic repertoire acquire a problematic character. One of the artist's means of accomplishing this is to establish conflicting associations between objects, thereby releasing a provocative and poetic force that is otherwise inactive. The mechanisms employed to create such conflicts are varied: changing the habitual location of a familiar scene; reversing the traditional order of elements; or modifying the scale of objects in relation to their settings. The aim of these operations is to disconcert the viewer and reveal possible alternatives to what seems to be forever fixed and unchanging.

24 The Sentimental Colloquy (The Guides), *1937. From wooden balusters and cannons arise two characters absorbed in a mysterious moonlit dialogue.*

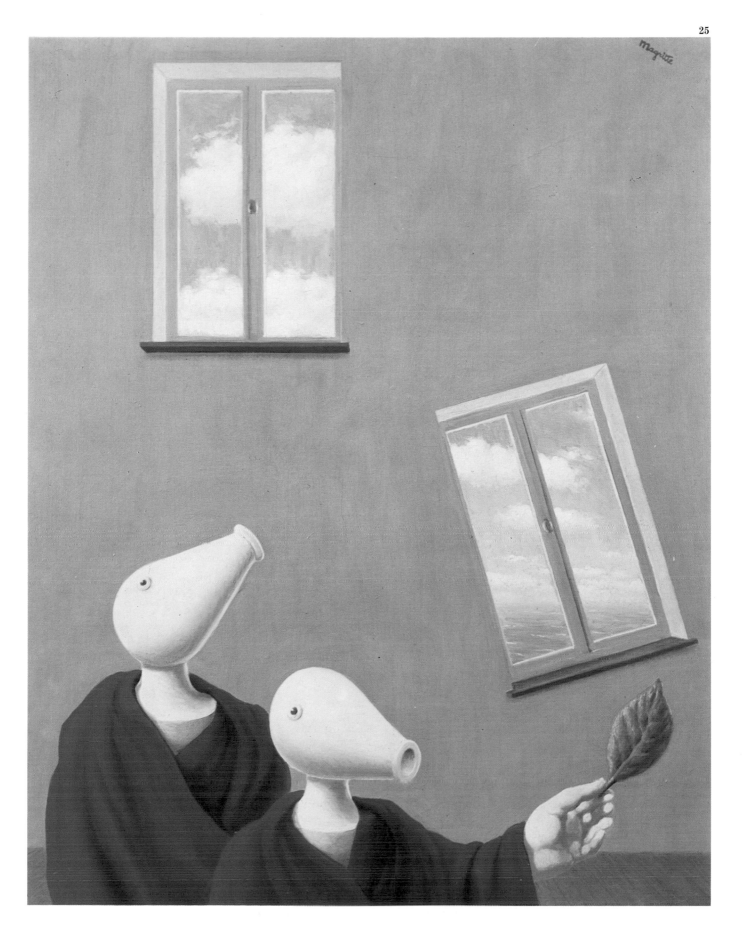

25 Natural Encounters, *1945. The leaf that the figure on the right holds in its hand is a reference to Magritte's 1929 picture-text* Words and Images, *in which "cannon" is proposed as a substitute for "leaf," as part of Magritte's experimentation with alternative names for objects.*

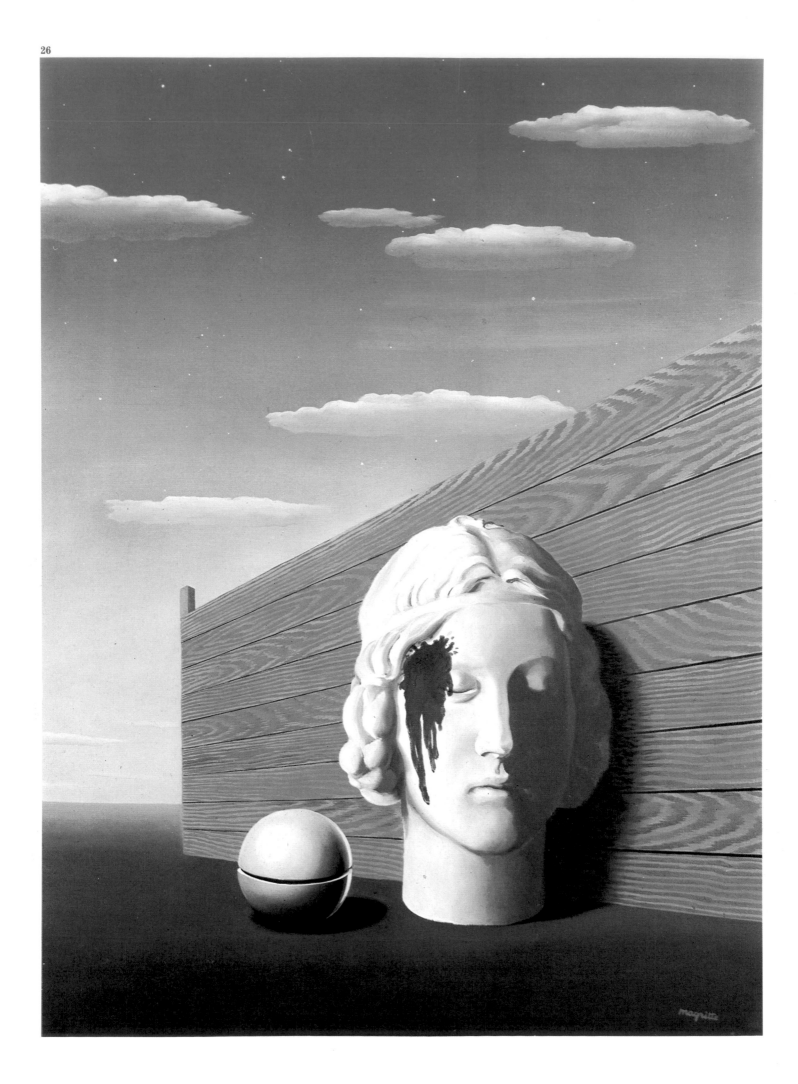

26 Memory, *1938. This stone classical bust, which is at the same time flesh and blood, evokes Giorgio de Chirico's* The Song of Love *(1914), which had a profound effect on Magritte.*

27 The Listening-Room, *1959. The giant apple in its tiny chamber is a prime example of Magritte's alteration of scale between an object and its setting. This contradictory operation is taken a step further by the opposition between the artificial condition of the room and the natural one of the apple, which finds itself dislocated from its outdoor setting.*

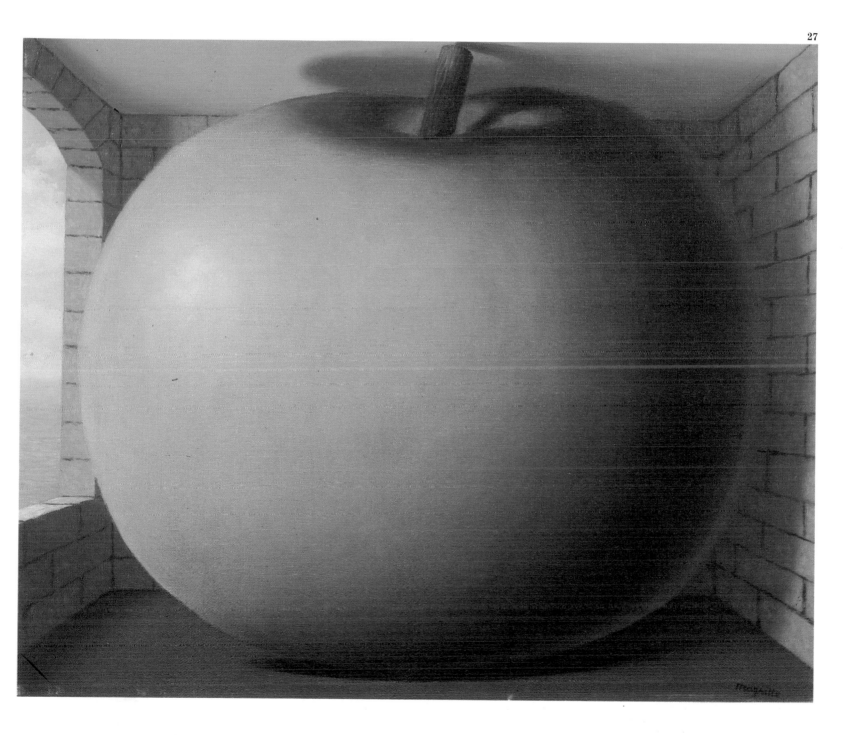

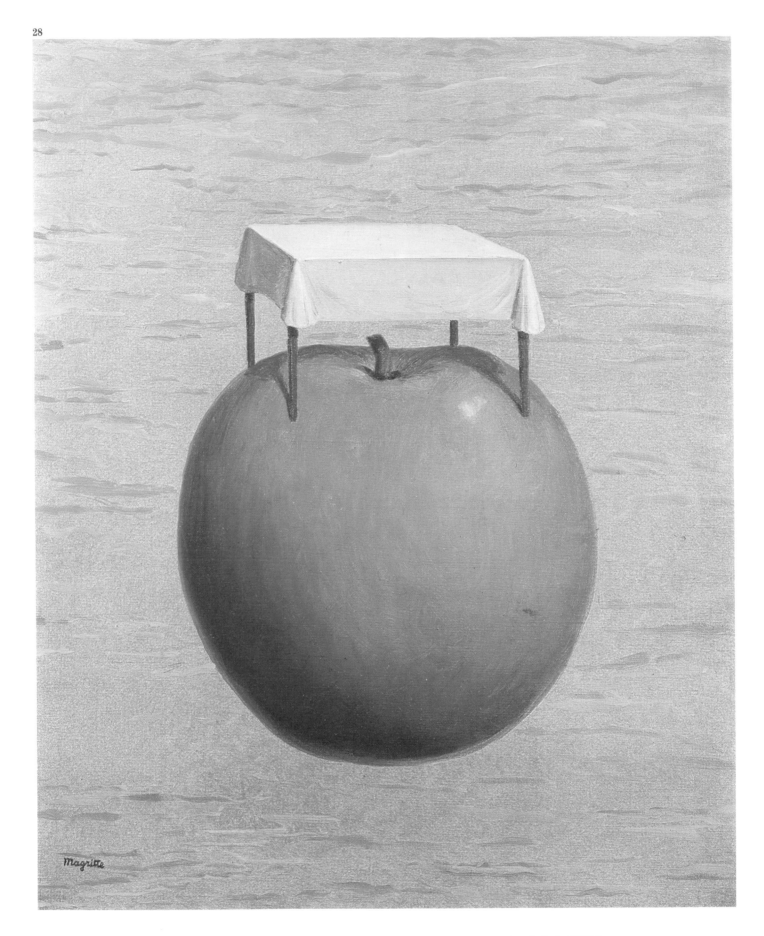

28 The Beautiful Realities, *1964. Magritte here turns the traditional artistic "still life"*
of fruit on a table literally upon its head. The relation between the apple and the table
are entirely reversed: scale, relative position, and location. They float in midair,
against a background of the sea or sky.

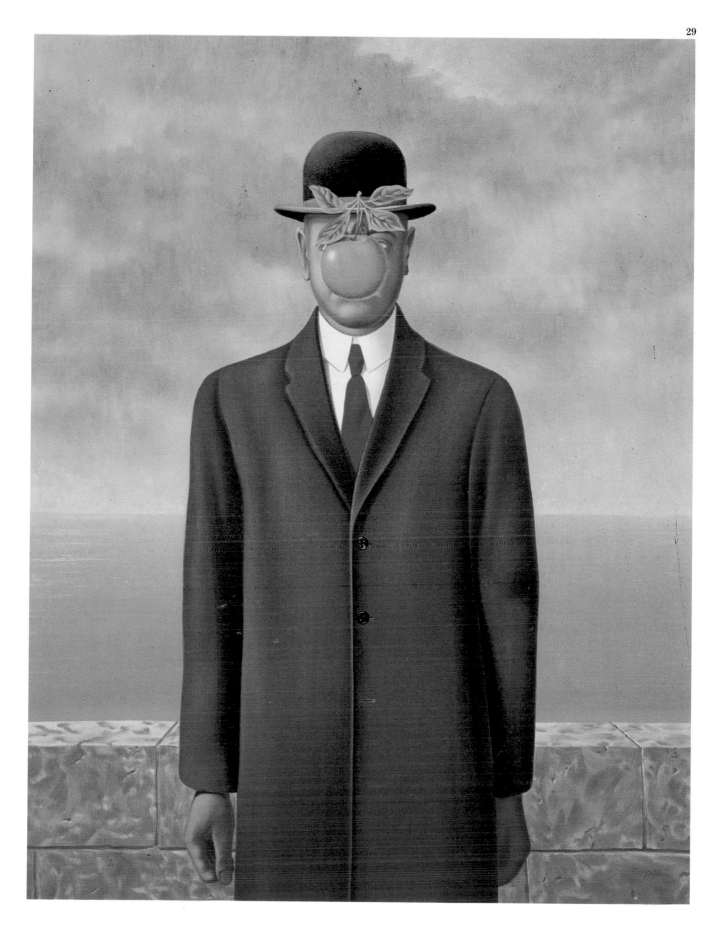

29 The Son of Man, *1964. Magritte wrote about this painting, "Everything we see hides another thing, we always want to see what is hidden by what we see." Interestingly, this painting came about from a friend's request for a self-portrait of the artist.*

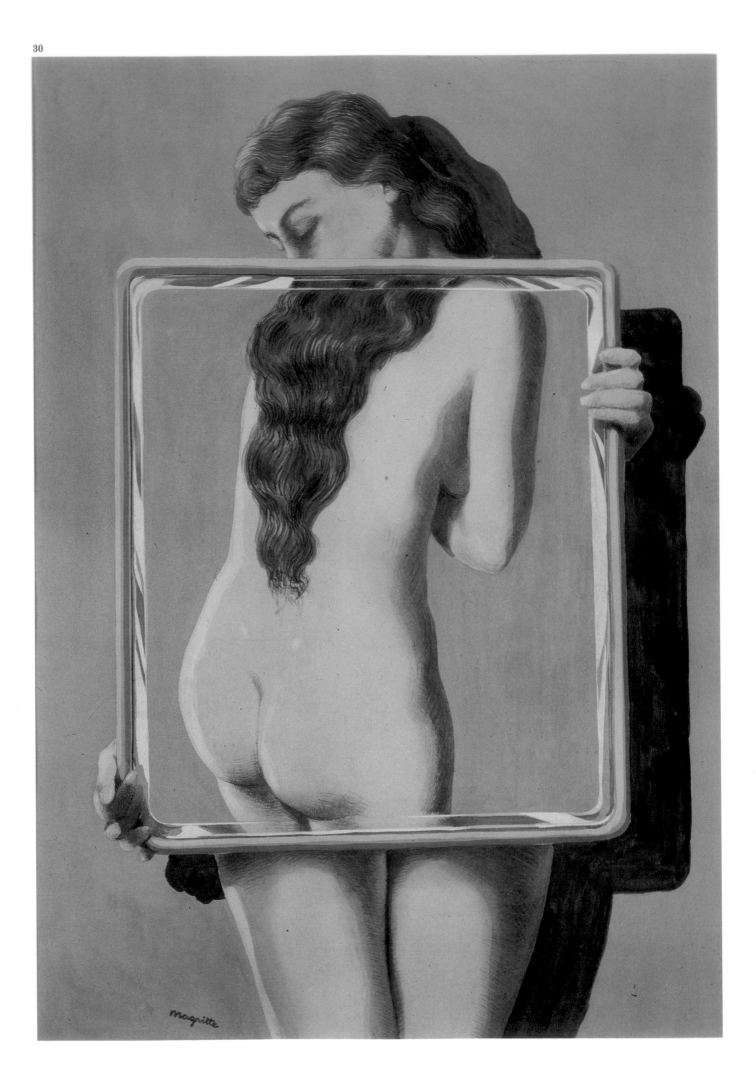

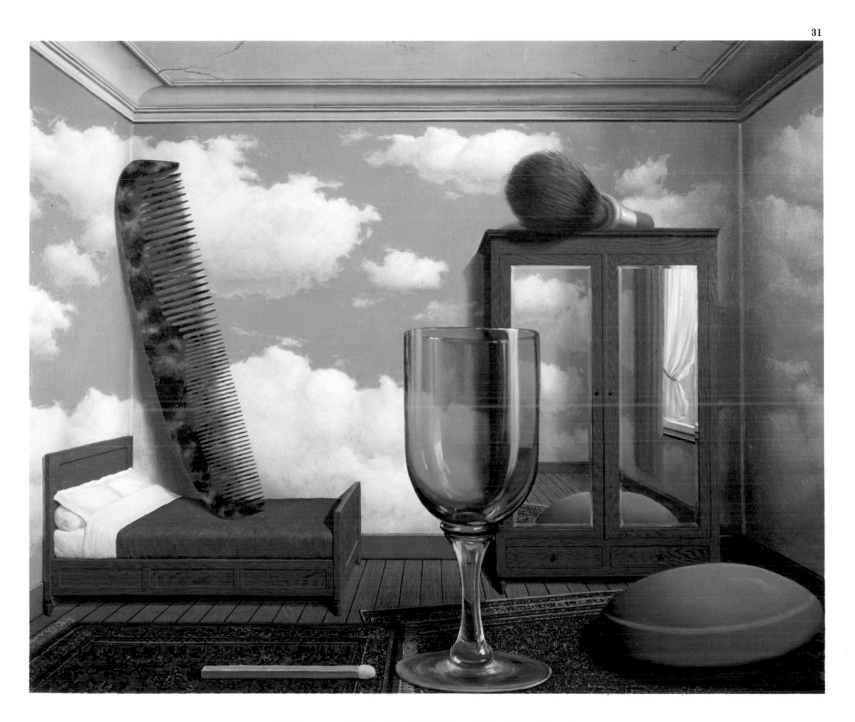

30 Dangerous Relationships, *1936. The artifice of the mirror is similar to that of the painted canvas blocking, or in fact revealing, the view that lies beyond, which Magritte uses in other paintings. But in this case, the reflected image simultaneously completes and contradicts the image that it hides.*

31 Personal Values, *1952. The perplexity of useless objects and machinery was a favorite theme in Dada and Surrealist circles. The change in the scale of these everyday objects diffuses their usefulness, while at the same time triggering their almost subversive powers.*

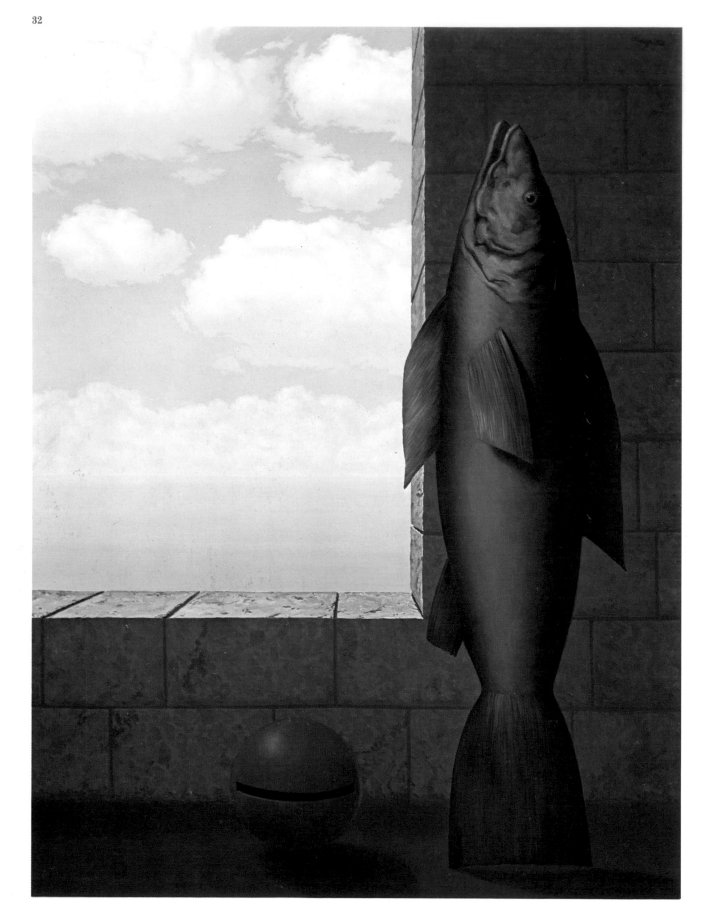

32 Search for the Truth, *1966. Again, the influence of de Chirico is clearly evident. A fish appears often in the canvases of de Chirico, as does the windowsill setting. The bell, however, is pure Magritte.*

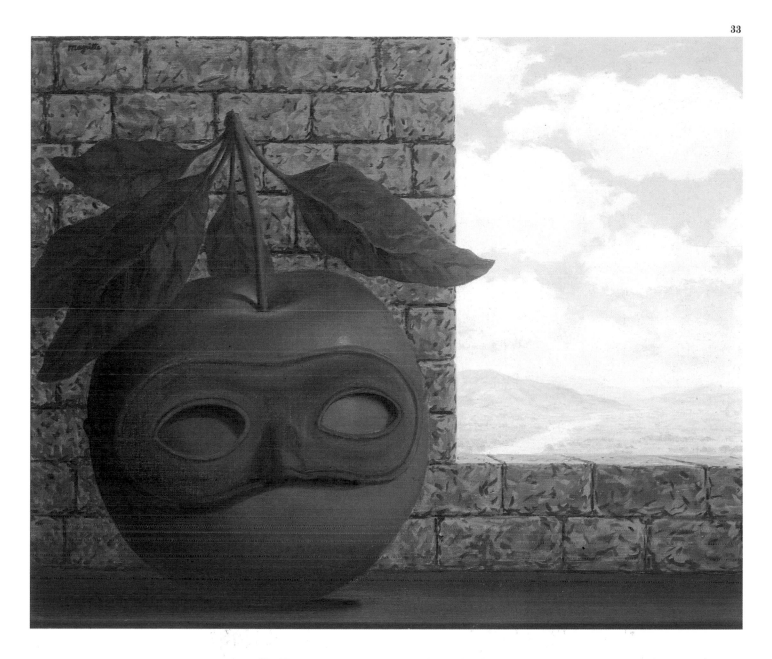

33 The Married Priest, *1961. Magritte painted several versions of this same theme for at least ten years. The title comes from a tale written by Jules Barbey d'Aurevilly in 1865, in which a married priest and his daughter are destined for a tragic end. The mask makes the apple disturbingly human.*

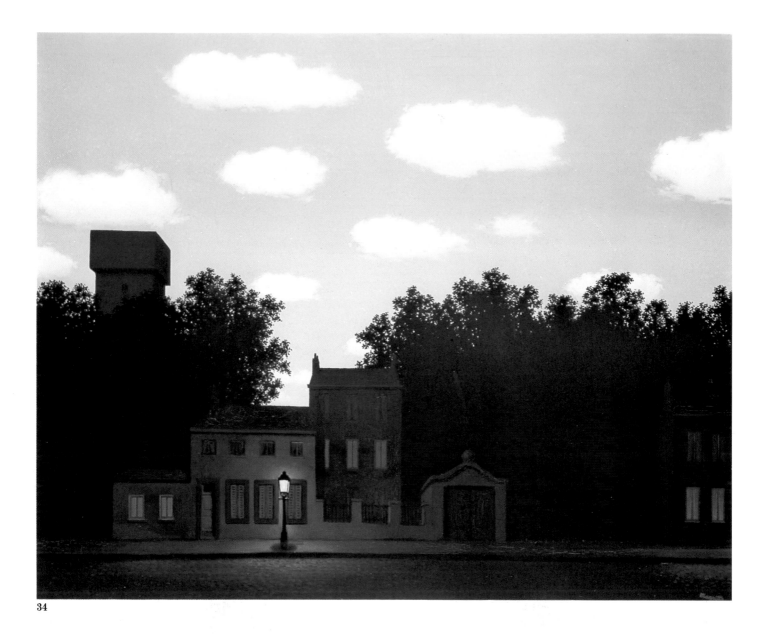

34

The Dominion of Light

Beginning in 1949 and until the time of his death, Magritte created sixteen paintings revolving around the same theme. The last of these works were never completed. They all bear the same title, *The Dominion of Light*, and they all involve a house or group of houses set amidst trees and illuminated by the electric lights from their windows and from streetlights. They were among the artist's biggest commercial successes. Oddly, while the heavens above are of a clear daytime blue, furrowed by the "good-weather" clouds often seen in Magritte's skies—nighttime reigns in the bottom half of the canvases. Yet the incompatibility of the sky above and the night below is not perceived at a first glance. The Dominion series comprises a painted manifesto of Magritte's artistic ideology, according to which painting is a tool that can reveal ideas and establish realities whose virtuality cannot be verified in everyday experience.

34 The Dominion of Light II, *1950. The meticulous realism of these paintings disguises the phenomenal impossibility of the scene—the co-existence of day and night—thereby making it paradoxically more disquieting.*

35 The Dominion of Light, *1954. In some of the variations of this series, the scene is transported to a lake, where the reflection of the electric lights on the surface of the water reinforces the overall effect of the composition.*

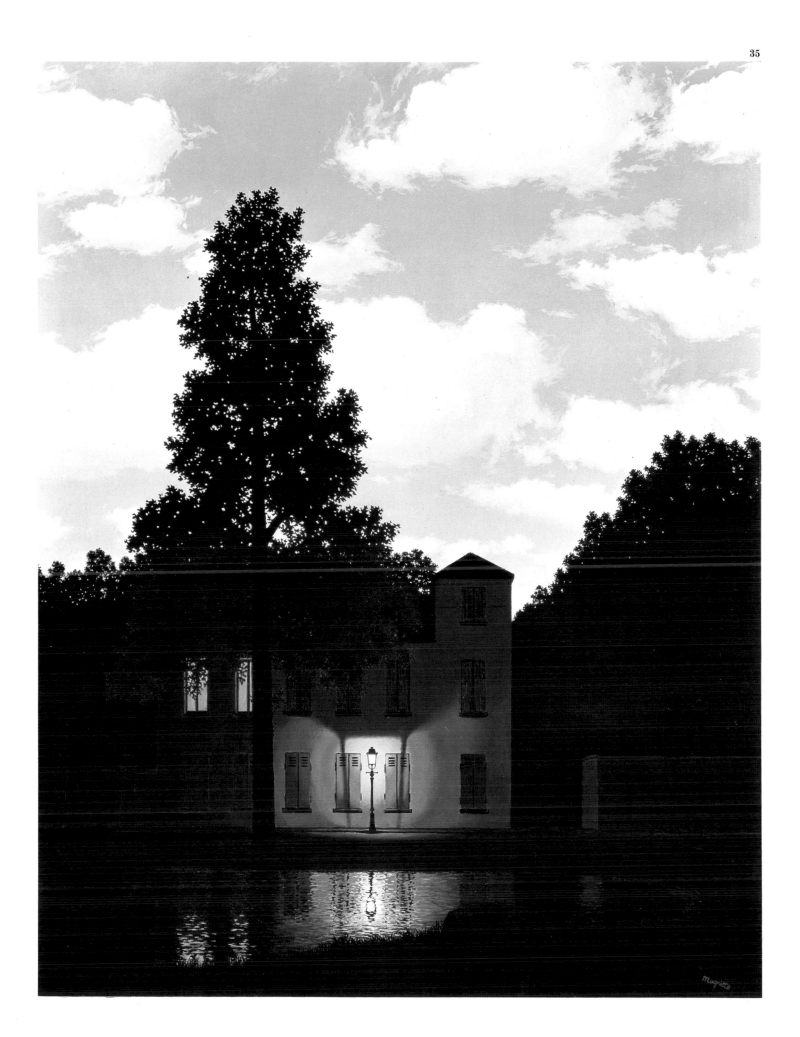

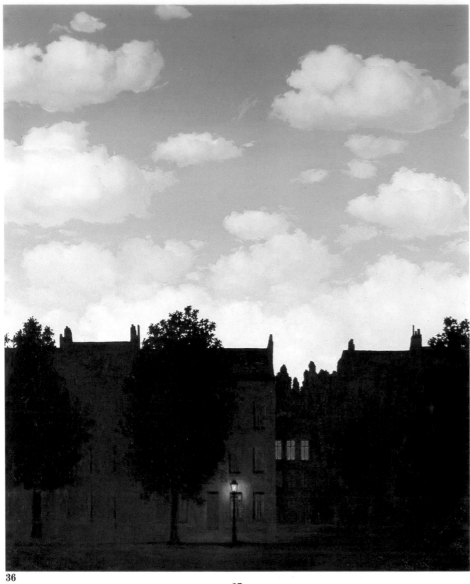

36

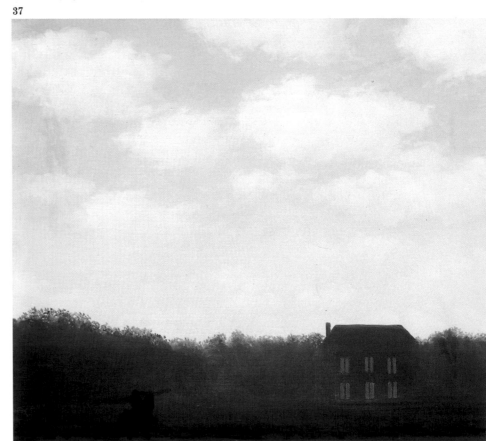

37

36 The Dominion of Light, *1948. The Dominion paintings were Magritte's most popular sellers. This is one of the earliest in the series.*

37 The Dominion of Light, *unfinished, 1967. Magritte worked almost obsessively on this series until the day of his death; the reconciliation of opposites was a Surrealist and Magrittean passion. This is one of the last canvases in the series, painted shortly before the artist's death.*

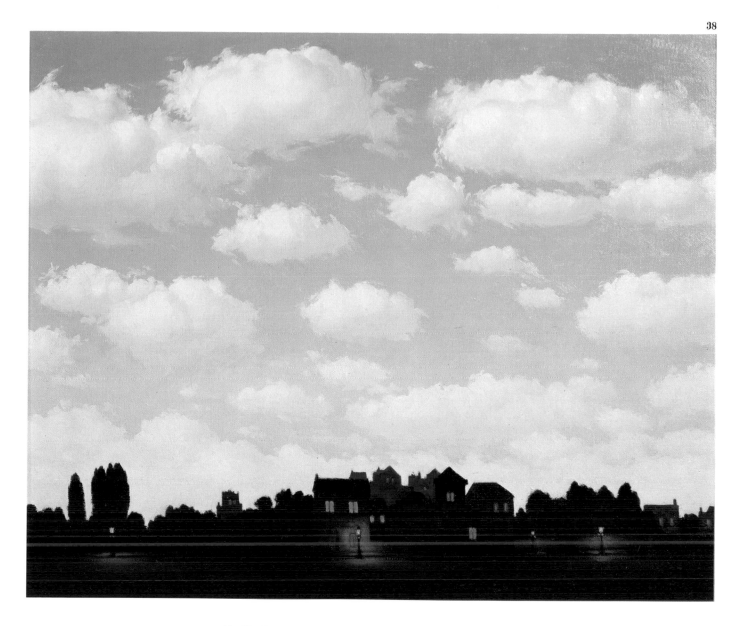

38 The Dominion of Light, *1953. As the view is much more
distant and the details are lost, the contrast between the radiant
brightness of the day and the nocturnal shadows in the lower
section becomes more evident.*

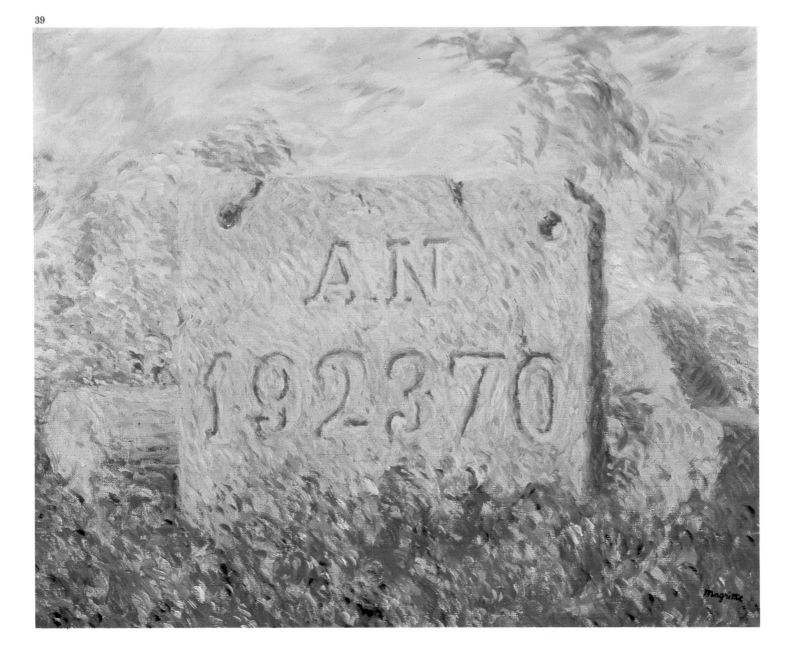

The "Renoir" Period

In 1943 Magritte's work took an unexpected twist. He produced a series of paintings in which his usual subdued, realistic manner of representation was replaced by images crackling with color and life and constructed with loose brushstrokes reminiscent of Renoir's late style. It became known as his "Renoir" or "Impressionist" period, although Magritte himself preferred to describe it as "Sunlit Surrealism." Ironically, this move towards cheerful, vivacious canvases took place in the midst of the Second World War, in stark contrast to the far more somber reality surrounding him. It is as though the painter subjected his work to a tour de force to demonstrate the ultimate displacement—brightness during wartime—and the power of art to transform one's state of mind. Magritte saw this body of work as a life-enhancing emergence from the darkness of Surrealism—and war. His critics, however, did not approve; they compared this departure to Giorgio de Chirico's return to classicism and Magritte was "excommunicated" from the ranks of the Surrealists. Magritte soon returned to his established style, but despite his detractors he remained convinced that these paintings were an essential part of his work.

39 The Smile, *1944. Instead of "contracting" the drab stone surface of so many other Magritte images, the tombstone here ironically assumes the vibrant colors from a surrounding field of flowers. Of its title Magritte wrote: "[it] is neither gratuitous nor arbitrary: the picture, by what it conjures up, causes the spectator to smile a peculiar smile and this justifies its title."*

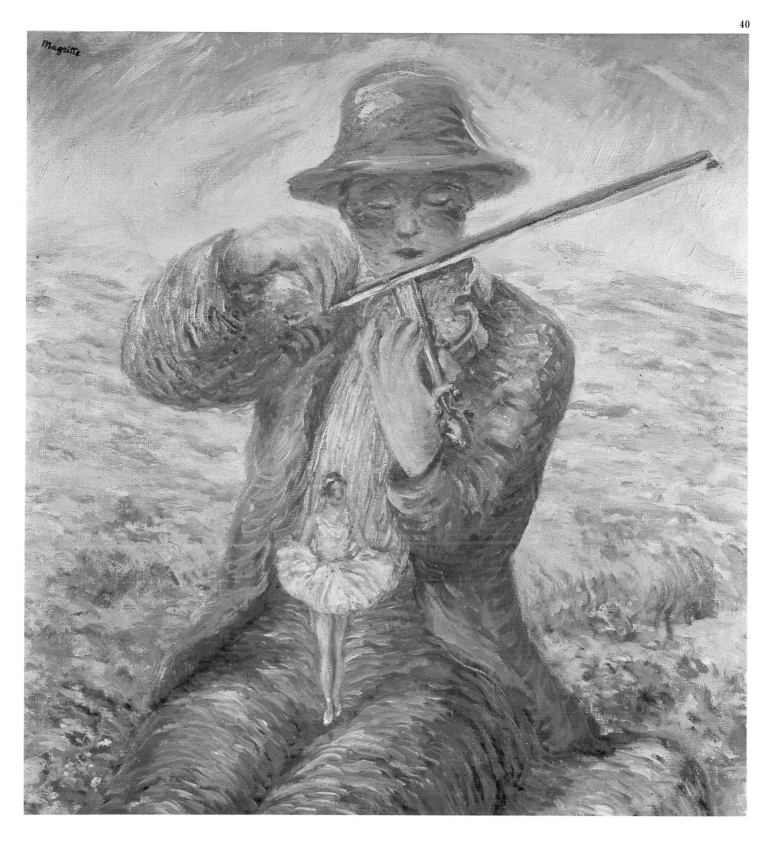

40 The First Day, *1943. This painting from Magritte's war-time*
"Impressionist" phase is probably the closest to the paintings that
Renoir executed at Les Collettes toward the end of his life. A sense
of pleasure and fulfillment dominate the scene; a ballerina emerges
from the violinist's groin, an image that Magritte rehearsed
earlier in Spring Eternal.

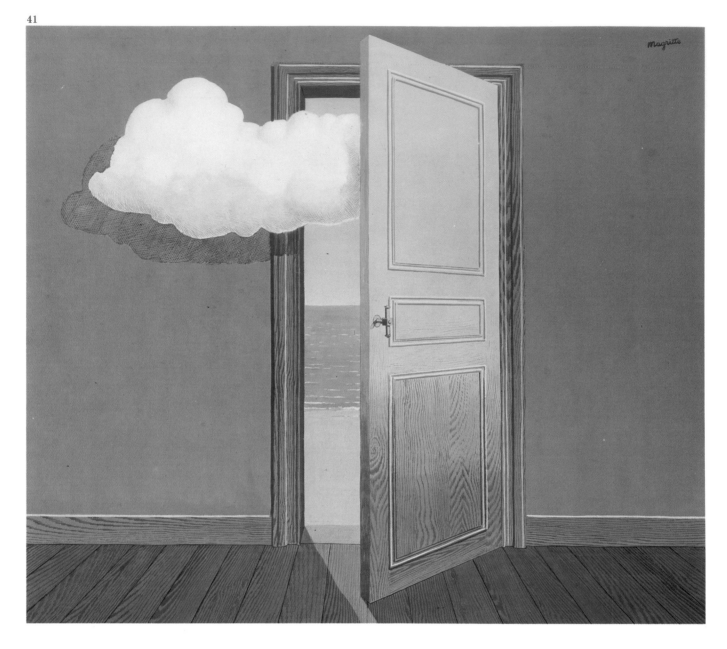

Interior and Exterior

The transition between interior and exterior is explored in many of Magritte's paintings. Doors, windows, frames, and mirrors are recurring elements in his works, functioning often in perplexing ways—a cloud enters a house through an open door, a vase of flowers becomes a window onto a landscape, and a painting before a window replaces the fragment of the vista that it represents. This last method—that of a painting within a painting depicting the same landscape that the canvas hides—has produced some of Magritte's best-known works. The idea of a painting as a virtual window has been at the root of western art since the Renaissance. Magritte exhausts the conceptual possibilities of this metaphor and turns it into a meditation on the nature of painting versus reality: the objects in his painting, he explained, are "at the same time inside the house, within the painting and without, and in the real landscape—which, in turn, is also a painted landscape. Their existence in two different spaces at the same time is similar to existing in both the past and the present simultaneously."

41 Poison, *1939. The door's spatial mediation becomes a poetic mediation not only by letting in the cloud, but also by taking on the color and appearance of the sea and the sky outside.*

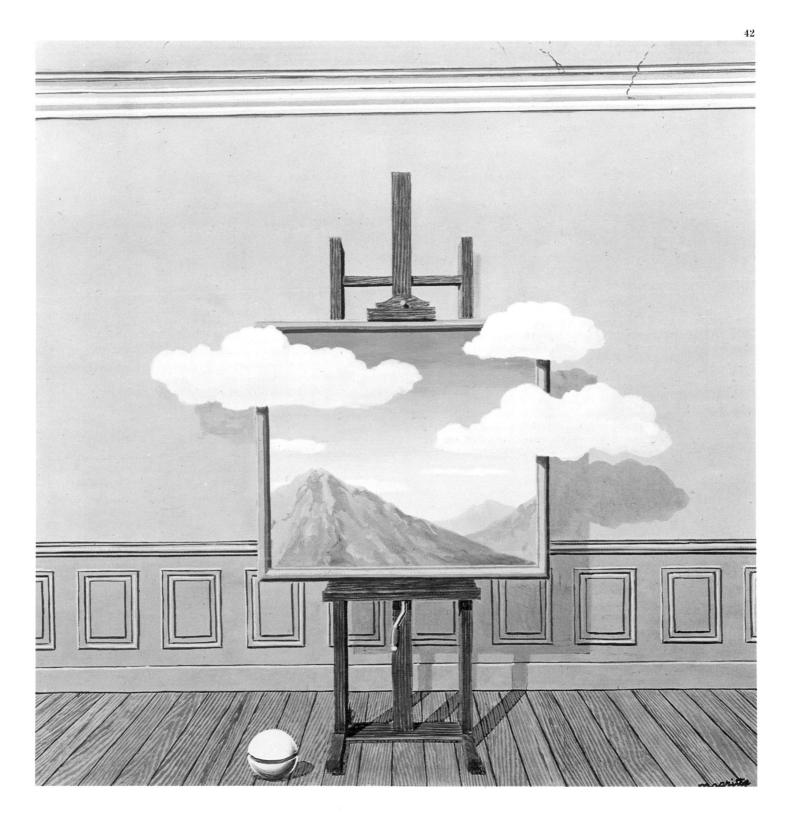

42 The Clouds, *1939. The painting literally becomes a window,
invading the interior space in which the easel stands, by letting in
the clouds from the painted mountain landscape on the canvas; it
is also a metaphor for the relation between painting and viewer.*

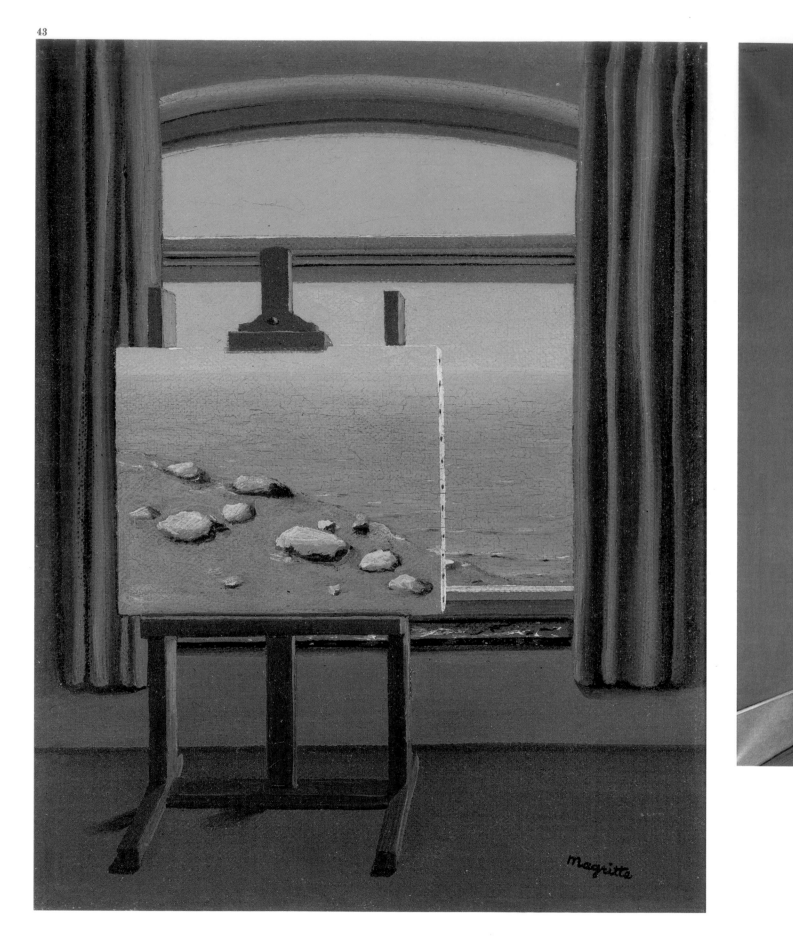

43 The Human Condition, *1934. This is one of the earliest paintings in which, using an easel placed before a window, Magritte explored the relationship between painting and reality. It comments on the way in which painting can invade the natural landscape, just as the painted clouds in the previous painting invaded a human-made landscape.*

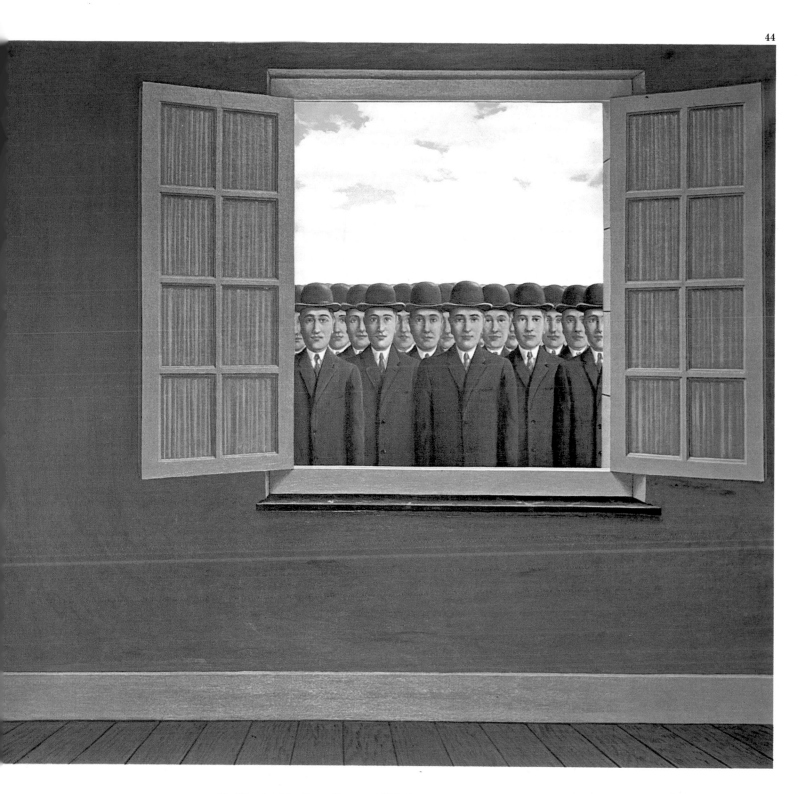

44 Month of the Grape-Harvest, *1959. The frieze of bowler-hatted Magrittean characters behind the window can almost be viewed as a poetic mirror, a sort of metaphor of the self-indulgent and predictable perception that the painter has set out to subvert in the viewer by forcing one "to think in a different manner."*

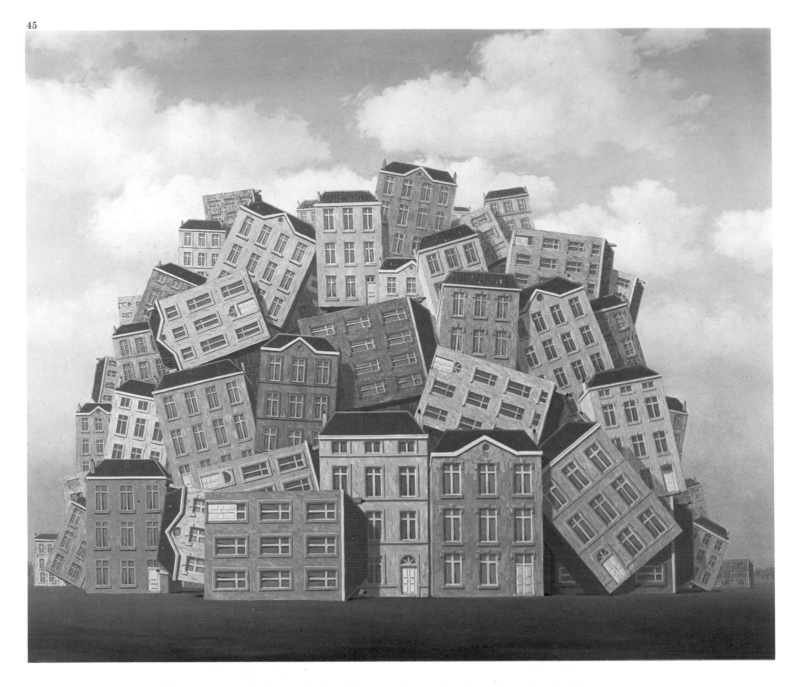

45 The Bosom, *1961. This picture results from a complex series of mutations: a jumbled heap of ashlar turning into houses, to which it is functionally related. At the same time, the regularity of the house-like forms contrasts with the arbitrariness of their accumulation.*

46 Memory of a Journey, *1955. This petrified scene is somehow*
mysteriously illuminated by the light cast from a stone candle.

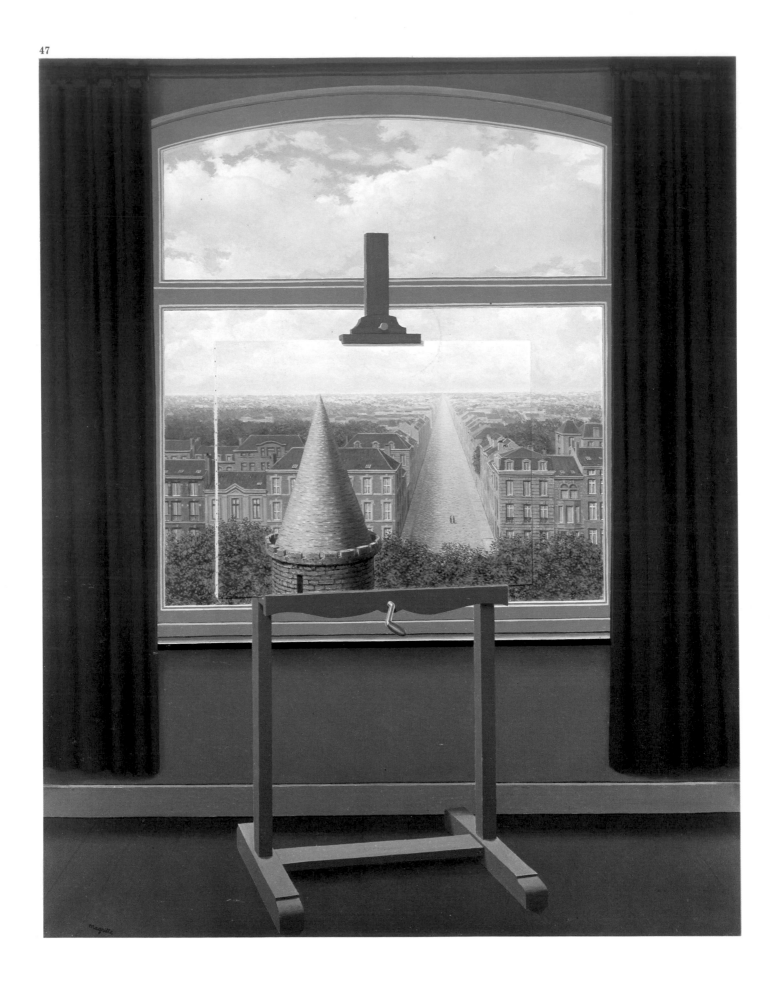

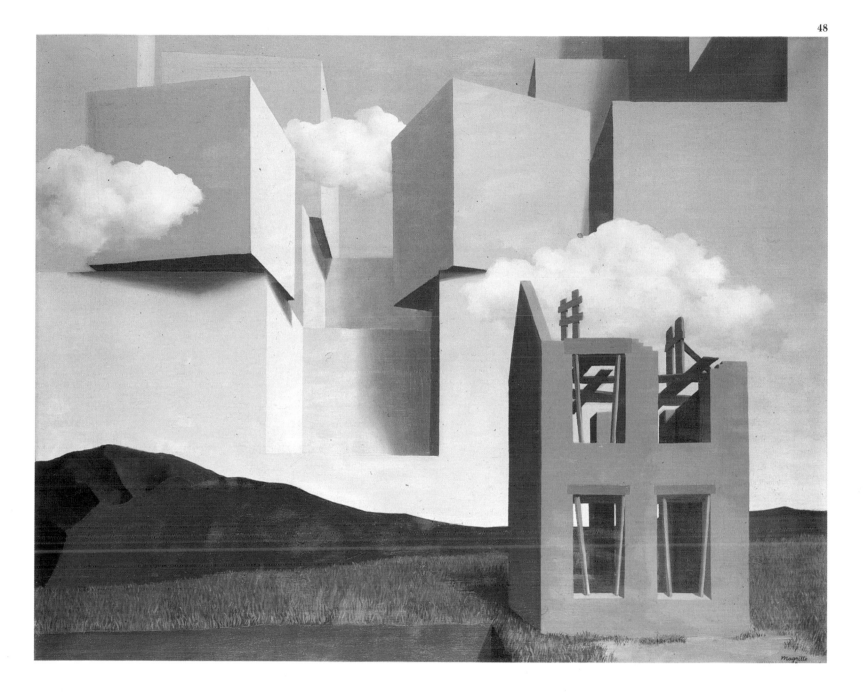

47 Where Euclid Walked, *1955. Named for the well-known
mathematician, this painting plays with two triangular forms. It
is also an imaginative look at the landscape as painting.*

48 The Unmasked Universe, *1932. In a characteristic Magrittean
inversion of traditional order, the sky appropriates the geometric
order of a building, which, in turn, has been turned into a ruin by
the arbitrariness of nature.*

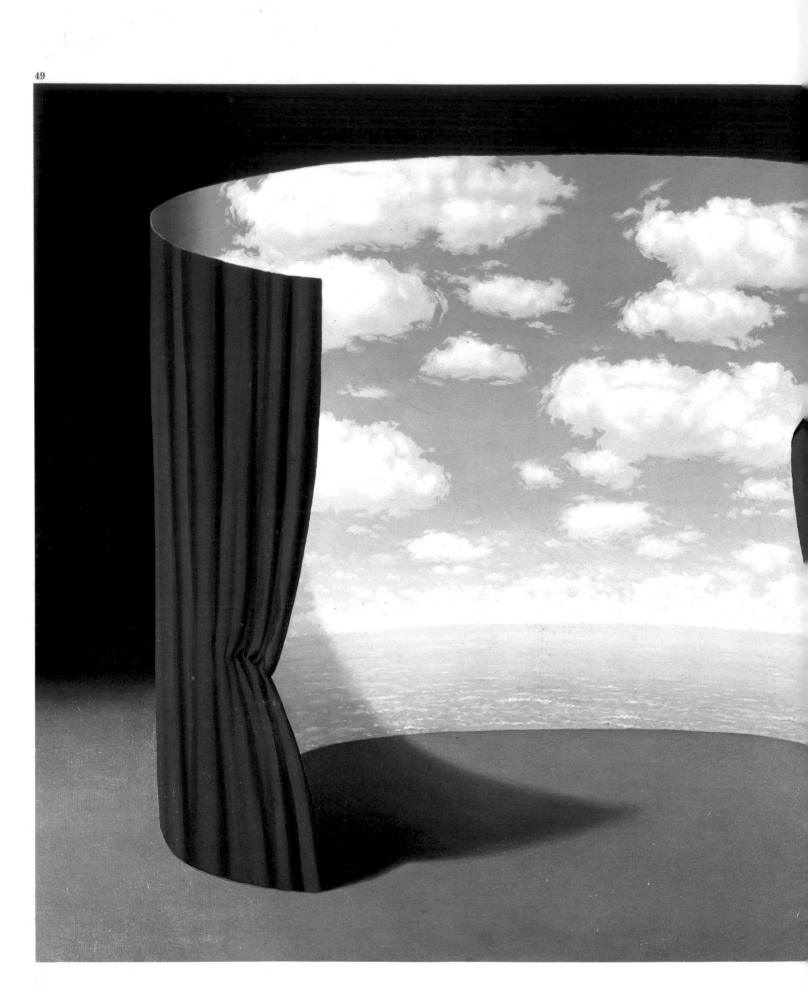

49 The Memoirs of a Saint, *1960. The curving seascape, enclosed in a paradoxical stage, reveals the roundness of the world—a well-known fact, but one that is not otherwise visible to the naked eye. The folded upper right corner, however, adds an enigmatic element.*

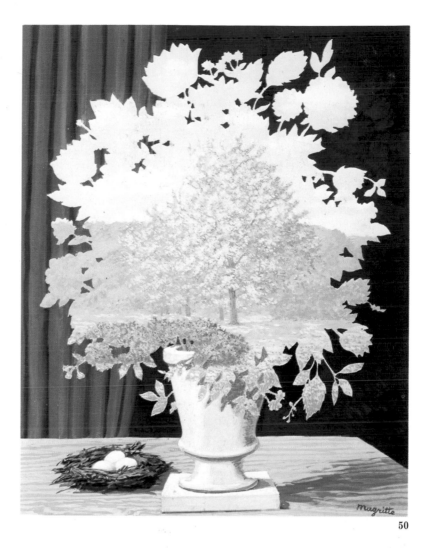

50

50, 51 Plagiarism, *1960*. The Country of Marvels, *c. 1960. Two vases of flowers act as windows onto the natural world from which they come.*

51

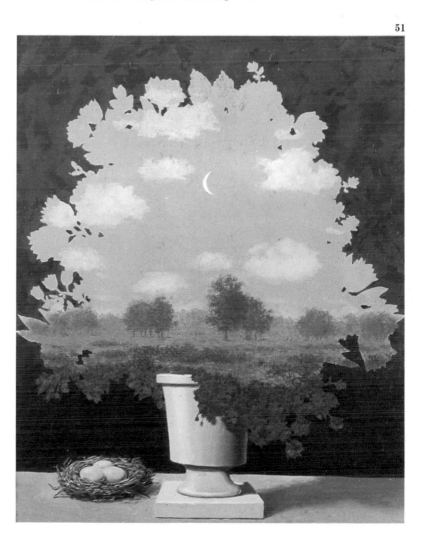

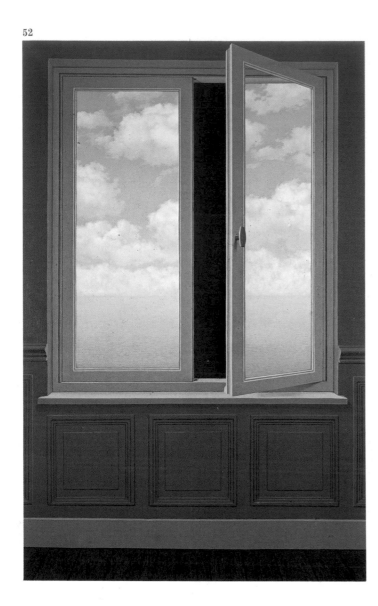

52 The Field-Glass, *1963. What lies behind the door, clear blue skies or the void? Magritte here illustrates how "an object can be problematic"; the problem explored is the mediating function of the window between two distinct but complementary spaces.*

53 The Call of Blood, *1961. The opposition of exterior and interior is compounded by the opposition of the natural and the artificial.*

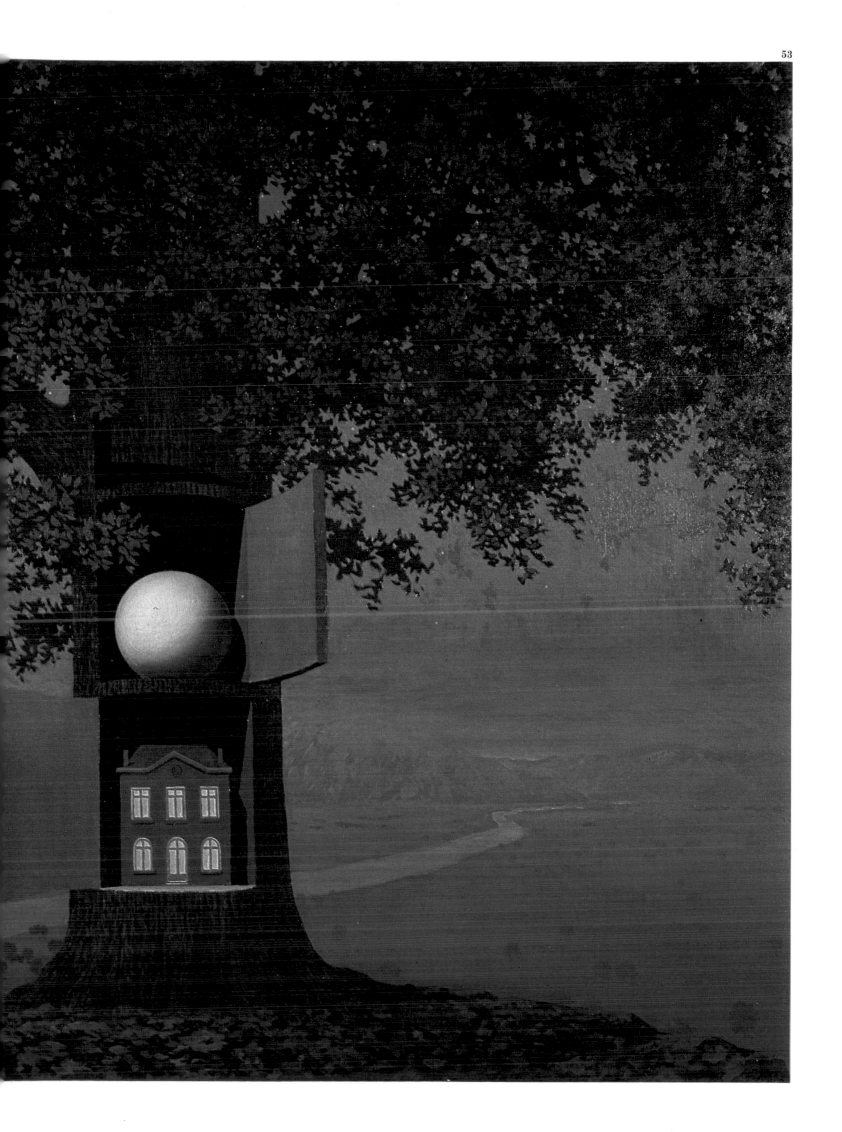

54

Absence and Presence

"For me," Magritte once wrote, "the concept of a picture is an idea of one or more things that can be made visible through my painting.... The idea is not itself visible in the painting: an idea cannot be seen with one's eyes." The rhetorical techniques that Magritte employs in his paintings amount to a meditation on the presence and the absence of things. These fundamental qualities are not to be found in the objects themselves, rather they arise from their interaction with other objects and with the viewers. Painting however, or at least the conceptual type of painting in which Magritte was interested, can employ and make visible the absence of an object. His paintings are problematic hypotheses of reality; they underscore its mystery, without providing a solution. This is why Magritte always shunned descriptive or explanatory titles: "titles must provide a supplemental protection, discouraging any attempt to reduce genuine poetry to a game with no consequences."

54 Bather, *1923. The flat, linear stylization of this early work betrays the influence of Robert Delaunay and the Futurists, which later gave way to more Surrealist imagery.*

55 The Unexpected Answer, *1933. The artist described this painting as showing "a closed door of a bedroom through which a shapeless hole reveals the night."*

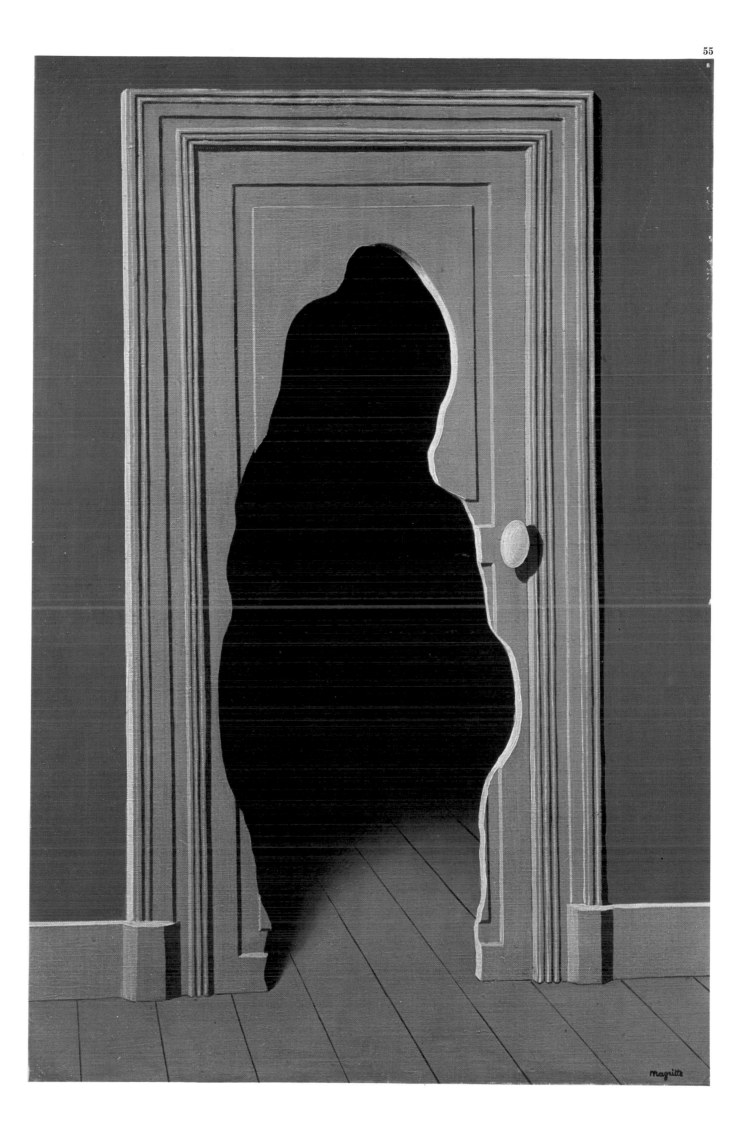

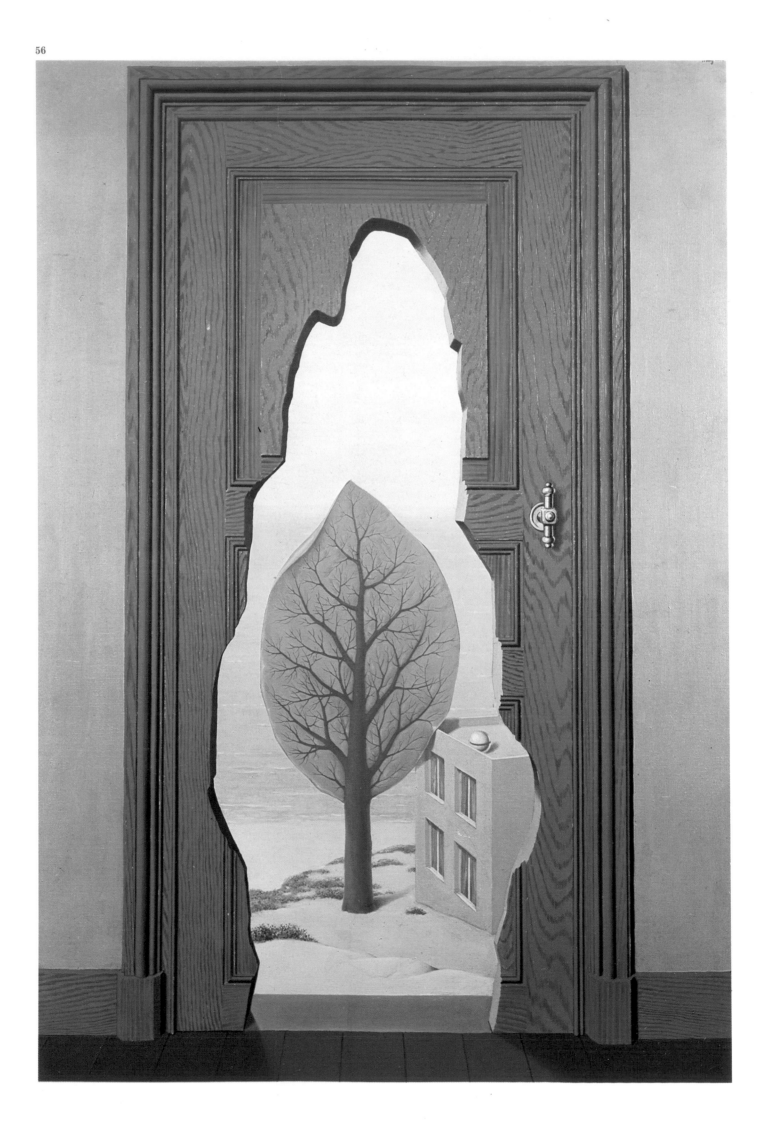

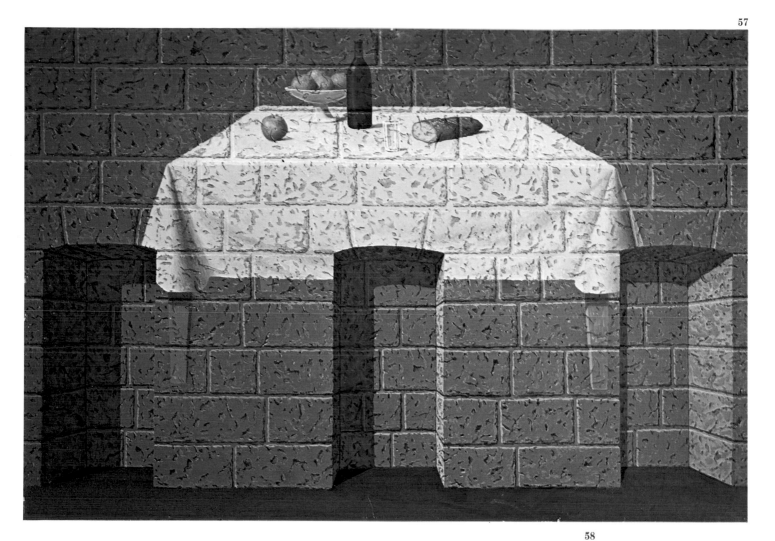

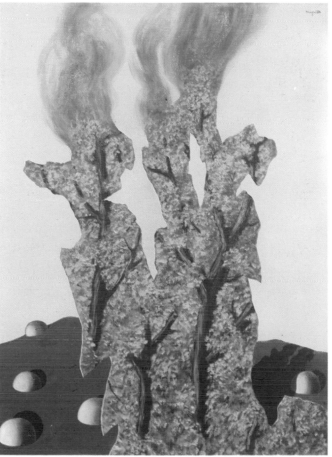

57 The Endearing Truth, *1966. This painting was inspired by Leonardo da Vinci's* Last Supper, *which Magritte saw in the summer of 1966. The table and still life on top of it are projected onto the wall as though a scene from a movie; what once had three dimensions now has only one.*

58 Countryside III, *1927. This painting of strange trees vanishing into a slow fire resembles the early collages of Max Ernst.*

56 The Amorous Vista, *1935. The darkened interior is now transformed into a bright landscape with a tree, a house, and the sea.*

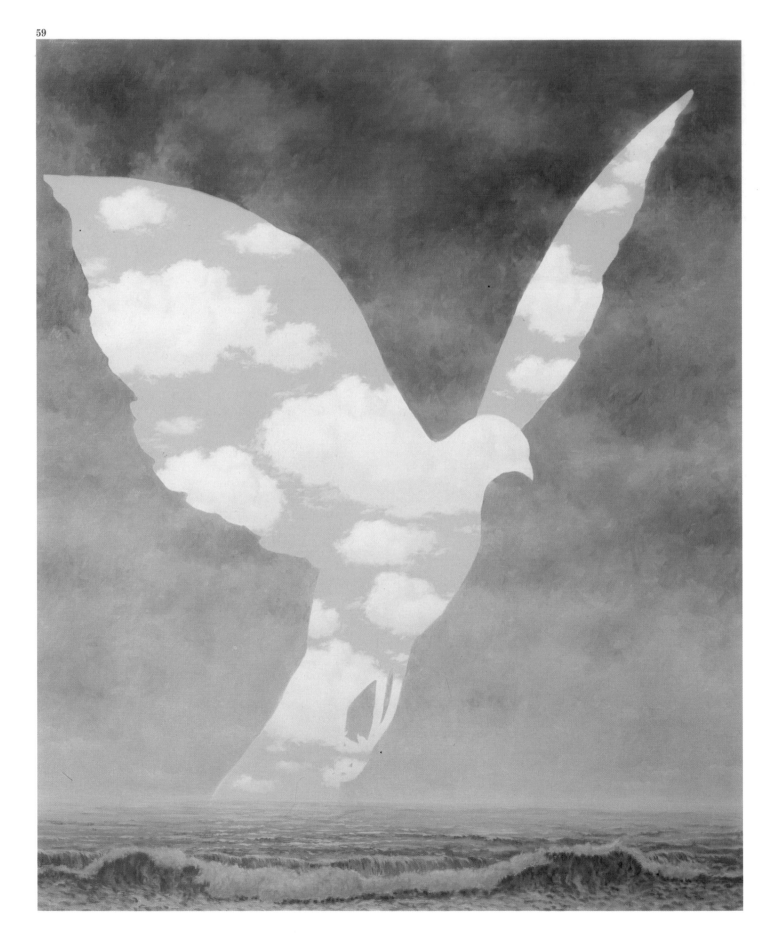

59 The Great Family, *1963. "Bird in the sky, crossed by skies," the poet Henri Michaux wrote of this painting. A bird of prey, emerging from the water, is one of Magritte's finest examples of the relativity of borders to presence and absence.*

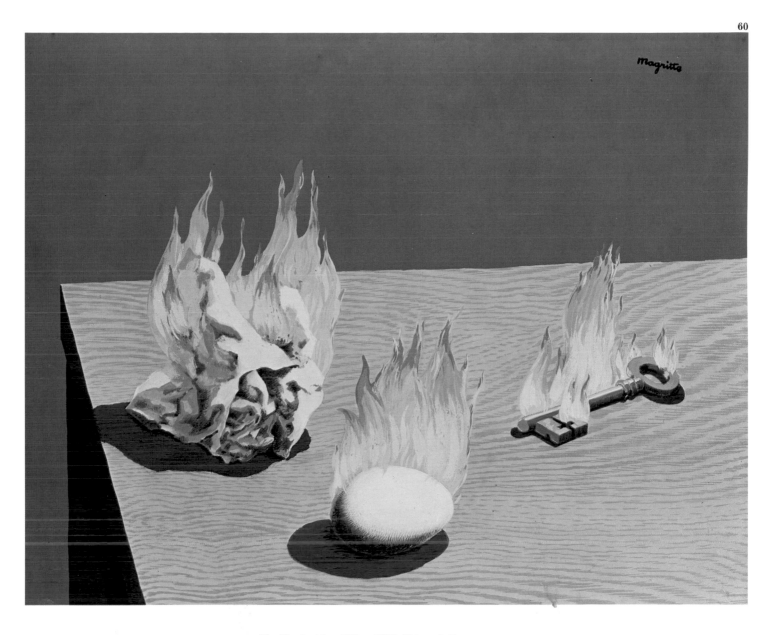

60 The Ladder of Fire, *1939. This painting, Magritte said, "granted me the privilege of experiencing the same emotion felt by the first men who produced a flame by striking together two pieces of rock." In a poetic twist, however, the painter depicts as ablaze two incombustible objects, alongside a burning piece of paper.*

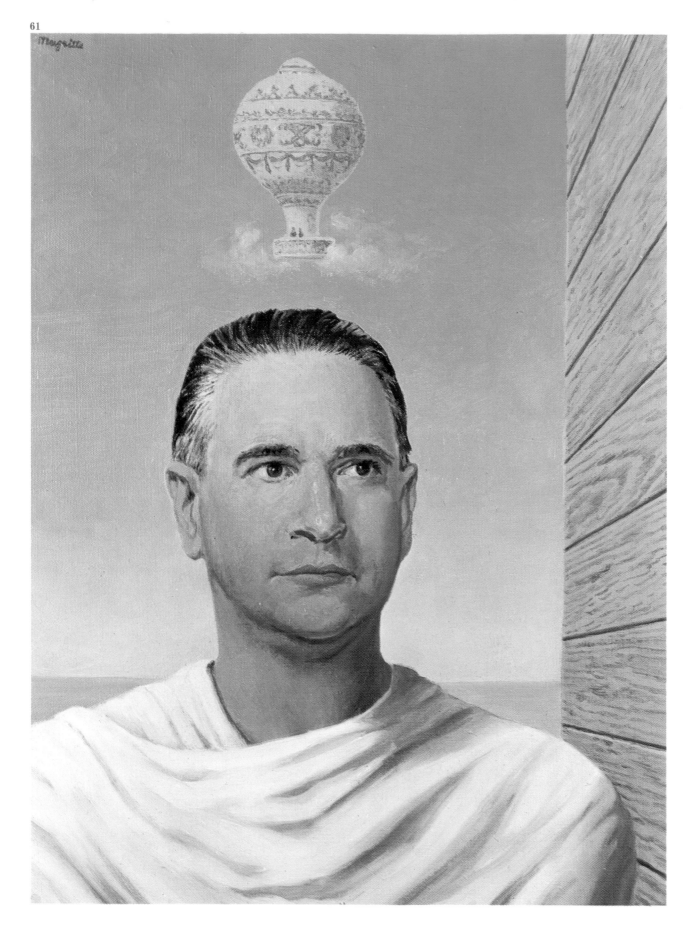

61 Justice Has Been Done, *1958. The character dressed as a classical tribune is
Harry Torczyner, Magritte's lawyer and good friend, and later a scholar and collector
of the artist's work. The balloon over his head is apparently an allusion to Torczyner's
love of travel.*

62 Carte Blanche, *1965. Up until the end Magritte continued to be fascinated by the
difference between the visible and that which is not visible—as distinct from the
"invisible." This painting is a variation on his paintings before a window.*

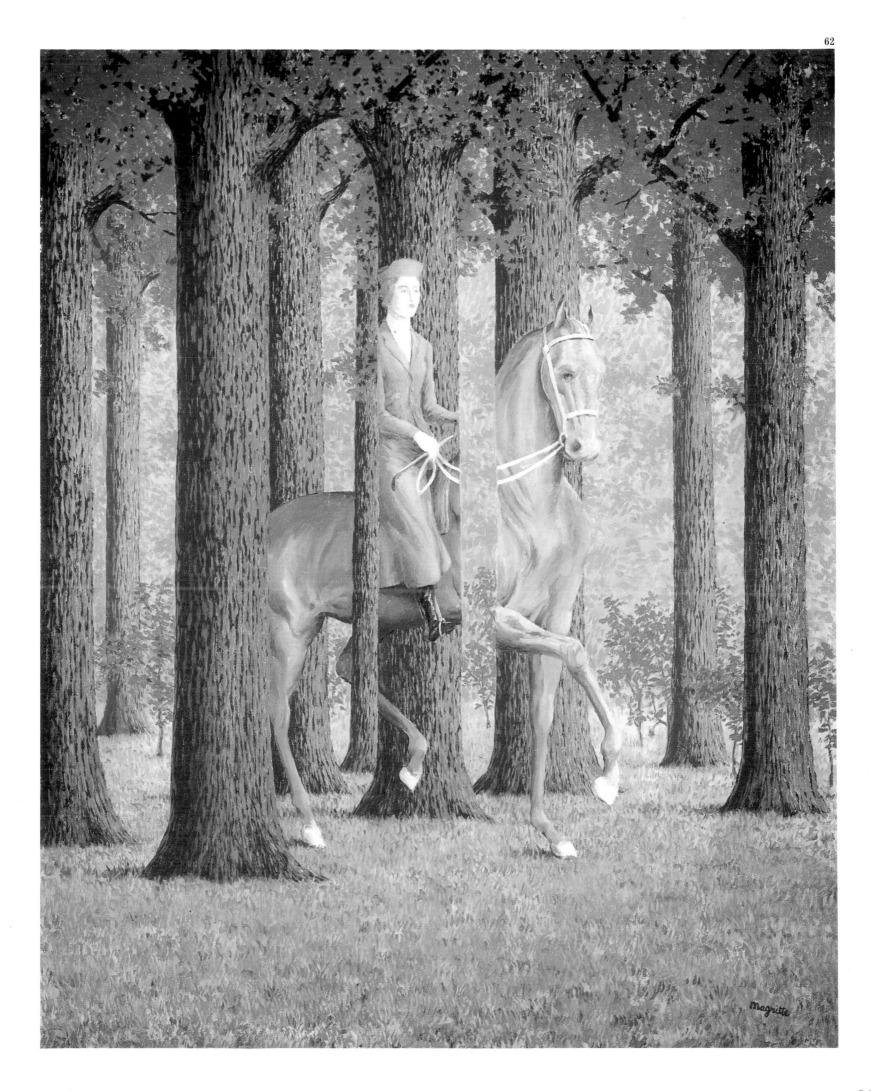

List of Plates

42 The Clouds, *1939. Gouache, 13½ × 13" (34.3 × 33 cm).*
Private collection, Belgium

43 The Human Condition, *1934. Oil on canvas, 10 × 7⅞"*
(25.5 × 20 cm). Private collection. Photo: Giraudon

44 Month of the Grape-Harvest, *1959. Oil on canvas, 51⅛ × 63"*
(130 × 160 cm). Private collection, Paris

45 The Bosom, *1961. Oil on canvas, 35⅜ × 43¼" (90 × 110 cm).*
Private collection, Brussels

46 Memory of a Journey, *1955. Oil on canvas, 63¾ × 51⅛"*
(162 × 130 cm). The Museum of Modern Art, New York

47 Where Euclid Walked, *1955. Oil on canvas, 64⅛ × 51⅛"*
(163 × 130 cm). The Minneapolis Institute of Arts, Minneapolis

48 The Unmasked Universe, *1932. Oil on canvas, 29½ × 35⅞"*
(75 × 91 cm). Private collection. Photo: Giraudon

49 The Memoirs of a Saint, *1960. Oil on canvas, 31½ × 39⅜"*
(80 × 100 cm). The Menil Collection, Houston

50 Plagiarism, *1960. Gouache, 12⅝ × 9⅞" (32 × 25 cm).*
Private collection, New York

51 The Country of Marvels, *c. 1960. Oil on canvas, 21⅝ × 18⅛"*
(55 × 46 cm). Private collection, Brussels

52 The Field-Glass, *1963. Oil on canvas, 68⅞ × 45⅝"*
(175 × 116 cm). The Menil Collection, Houston

53 The Call of Blood, *1961. Oil on canvas, 35⅜ × 39⅜"*
(90 × 100 cm). Private collection, Brussels

54 The Bather, *1923. Oil on canvas, 19⅝ × 39⅜" (50 × 100 cm).*
Mr. and Mrs. Berger-Hoyez Collection, Brussels

55 The Unexpected Answer, *1933. Oil on canvas, 31⅞ × 21½"*
(81 × 54.5 cm). Musées Royaux des Beaux-Arts de Belgique,
Brussels

56 The Amorous Vista, *1935. Oil on canvas, 45⅝ × 31⅞"*
(116 × 81 cm). Private collection, Brussels

57 The Endearing Truth, *1966. Oil on canvas, 35⅛ × 47½"*
(89.2 × 120.5 cm). The Menil Collection, Houston

58 Countryside III, *1927. Oil on canvas, 28⅞ × 21¼"*
(73.5 × 54 cm). Isy Brachot Gallery, Brussels

59 The Great Family, *1963. Oil on canvas, 39⅜ × 31⅞"*
(100 × 81 cm). Private collection. Photo: Giraudon

60 The Ladder of Fire, *1939. Gouache, 10⅝ × 13⅜"*
(27 × 34 cm). Edward James Foundation Collection,
Chichester, Sussex

61 Justice Has Been Done, *1958. Oil on canvas, 15½ × 11½"*
(39.5 × 29.2 cm). Private collection, New York

62 Carte Blanche, *1965. Oil on canvas, 31⅞ × 25⅝"*
(81 × 65 cm). National Gallery of Art, Washington, D.C.
Photo: Giraudon

Selected Bibliography

Gablik, Suzi, Magritte, Thames and Hudson, London, 1970
Hammacher, A. M., Magritte, Harry N. Abrams, New York, 1974
Larkin, David, Magritte, Ballantine Books, New York, 1972
Sylvester, David, Magritte, Fonds Mercator, Antwerp, 1992
Torczyner, Harry, Magritte: Ideas and Images, Harry N. Abrams,
 New York, 1977
Whitefield, Sarah, Magritte, The South Bank Center, London, 1992

Series Coordinator, English-language edition: Ellen Rosefsky Cohen
Editor, English-language edition: Sarah Burns
Designer, English-language edition: Judith Michael

Library of Congress Catalog Card Number: 95–78427
ISBN 0–8109–4680–7

Copyright © 1995 Ediciones Polígrafa, S.A., and Globus Communicación, S.A.
Reproductions copyright © René Magritte. VEGAP, Barcelona, 1994
English translation copyright © 1996 Harry N. Abrams, Inc.

Published in 1996 by Harry N. Abrams, Incorporated, New York
A Times Mirror Company
Printed and bound in Spain by La Polígrafa, S.L.
Parets del Vallès (Barcelona)
Dep. Leg.: B.39.913-1995